M000024007

LEGENDARY l

OF

DETROIT

MICHIGAN

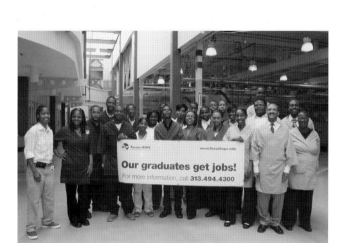

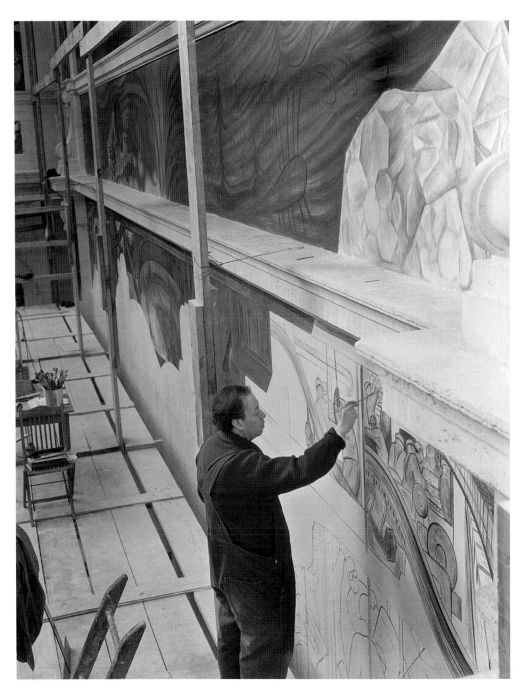

Diego Rivera
Rivera is shown at work on his *Detroit Industry* frescos. (Courtesy of the Detroit Institute of Arts.)

Page 1:
Members of a skilled trades class at Focus:HOPE proudly display the spirit of their organization. (Courtesy of Focus:HOPE.)

LEGENDARY LOCALS
—— OF ——

DETROIT

MICHIGAN

PAUL VACHON

LEGENDARY
LOCALS

Copyright © 2013 by Paul Vachon
ISBN 978-1-4671-0042-7

Legendary Locals is an imprint of Arcadia Publishing
Charleston, South Carolina

Printed in the United States of America

Library of Congress Control Number: 2012944788

For all general information, please contact Arcadia Publishing:
Telephone 843-853-2070
Fax 843-853-0044
E-mail sales@arcadiapublishing.com
For customer service and orders:
Toll-Free 1-888-313-2665

Visit us on the Internet at www.arcadiapublishing.com

Dedication
To the people of the city of Detroit—past, present, and future

And in loving memory of my Aunt Rose Shencopp (1926–2013)
And of my Aunt Brigid Rieger (1923–2013)

On the Cover: From left to right:
(TOP ROW) Harry Bennett, Ford Motor Company official (see page 119); Joyce Carol Oates, author (see page 70); Joe Louis, boxer (see page 106); Hazen Pingree, mayor of Detroit 1889–1999 (see page 24); Helen Milliken, feminist leader and first lady of Michigan 1969–1983 (see page 35).
(MIDDLE ROW) Roy Chapin, industrialist and politician (see page 48); Ed Davis, Detroit's first African American automotive dealer (see page 13); Marshall Fredericks, sculptor (see pages 76, 77); Viola Liuzzo, civil rights pioneer (see page 26); Eliel Saarinen, architect (see page 83).
(BOTTOM ROW) Robin Seymour, radio announcer (see page 62); Charles W. Wright MD, civil rights pioneer (see page 32); Ossian Sweet MD, civil rights pioneer (see page 17); Minoru Yamasaki, architect (see pages 88, 89); Arthur Johnson PhD, educator and civil rights pioneer (see page 29).
(All cover images courtesy of the Walter Reuther Library.)

CONTENTS

ACKNOWLEDGMENTS

Writing a book is never a project done in total isolation. Behind every author's name is a group of people whose indispensable help and dedication grease the skids of any title's progress—from concept to proposal, outline, writing, editing, designing, and proofing.

My editor, Tiffany Frary, deserves special praise. The Legendary Locals series is new to Arcadia, which no doubt made her task of mentoring authors more challenging. Her expertise and professionalism proved invaluable in guiding me through the writing and research.

Thanks also to senior editor Erin Vosgien, who provided assistance to Tiffany.

My deep gratitude also to the sources for the images contained in this book: Dr. Melba Boyd, Wayne State University; Scott Burnstein; Judith Cantor, Congregation Shaarey Zedek archives; Elizabeth Clemens and Mary Wallace, Walter P. Reuther Library for Urban and Labor Affairs at Wayne State University; Janet Durecki, Rabbi Leo M. Franklin Archives at Temple Beth El; George Eichorn; Dawn Eurich, Burton Historical Collection, Detroit Public Library; Emily Fijol, Michigan Women's Hall of Fame; Tony Jahn, Target Corporation archives; Paul Lenharp, Focus: HOPE; Stephanie Lucas, the Benson Ford Research Center; Rev. Tom Lumpkin, Day House; Pamela Marcil, Detroit Institute of Arts; Amanda Sansoterra, the Heidelberg Project; St. Bonaventure Monastery; and WJR-AM.

My thanks to my wife, Sheryl; my son Evan; and my mother-in-law, Mollie Stoffer, who helped brainstorm the list of subjects to include in the book.

Special thanks go to Ann Thropp for her invaluable assistance.

I also wish to honor the memory of the late Thomas Featherstone, archivist at the Walter Reuther Library. Mr. Featherstone graciously assisted me on my earlier projects, and he is truly missed by this author.

Unless otherwise indicated, all images appear courtesy of the Walter P. Reuther Library, Wayne State University.

INTRODUCTION

A great city owes its stature to generations past. As 21st-century Detroit labors to reinvent itself after decades of decline, it is aided by a reliance on its infrastructure of physical and human capital—past contributions made by noted architects, artists, businesspeople, entertainers, sports figures, and political and religious leaders. These individuals and groups made investments that continue to yield dividends today. Even community scoundrels have played a role.

But this should not come as a surprise. Detroit's history holds an uncanny ability to amaze even the well-versed student. The meteoric growth that came with the automobile industry; the high standard of living it produced; and the rise of a new, erudite culture are nothing short of astounding. The city's population of only 285,000 in 1900 swelled to some 1.8 million by 1950. The first quarter of the 20th century saw the construction of the Detroit Public Library, the Detroit Institute of Arts, and Orchestra Hall, plus numerous downtown movie houses known for their opulence. Luxury retailers, such as J.L. Hudson and Saks Fifth Avenue, and equally prestigious hotels, including the Book Cadillac, Statler, Leland, and Fort Shelby, all contributed to Detroit's new identity as "the Paris of the Midwest."

The history of any community, however, often unfolds in ways illogical and ultimately counterproductive. Such was the case with Detroit. The all-too-common blight in present-day Detroit is largely the result of past racial strife—a poignant example of the consequences of human fear and frailty.

In the aftermath of World War II, the goal of African American citizens to move to more desirable neighborhoods (encouraged by newly enacted civil rights laws) collided with the attitudes and prejudices of many white Detroiters. Blacks choosing to move out of the Paradise Valley area of the lower east side—the area where most had traditionally been segregated—were often greeted with violent resistance by neighborhood whites. In *The Origins of the Urban Crisis: Race and Inequality in Postwar Detroit*, author Thomas Sugrue writes:

> As the city's racial demography changed in the postwar years and as blacks began to move out of the center city, white neighborhood organizations acted to define and defend the invisible boundaries that divided the city. Their actions were, in part, an attempt to mark their territory symbolically and visibly, to stake out turf and remind outsiders that to violate those borders was to risk a grave danger.

Mid-20th century Detroit, so well known for its shining exterior, was built on the weak foundation of segregation and poor race relations—a negative legacy whose place in the city's history must be confronted as the community works toward a rebirth. At the time, however, city leaders proved incapable or unwilling to face or address these difficulties. Today, both city and suburb are worse off because of this error of history.

Despite this dark legacy, though, Detroit remains resilient. The first decade of the 21st century saw an influx of investment and new residents in the downtown and midtown areas that began to bring back to life long-dormant skyscrapers built alongside the pillars of the cultural district and Wayne State University. The contributions of today's movers and shakers benefit the city as a whole and build upon the contributions of the past.

Each individual and group that has impacted Detroit has a unique story. This book seeks to expose and reflect on these local people—the saintly, the sinister, the popular, and the obscure. A few figures, however, merit special mention. The influence of each represents a noteworthy turning point in Detroit's history.

Henry Ford is perhaps one of the most complex and baffling figures in both Detroit and US history. Contrary to popular belief, Ford invented neither the automobile nor the assembly line, yet no other

individual is more responsible for the birth and phenomenal growth of the industry. Despite his lack of formal education, Ford proved to be a brilliant student of both mechanical engineering and business. After establishing Ford Motor Company in 1903, he designed and marketed several early models of automobiles, each identified by a letter of the alphabet, and each an improvement over the last. Later, his iconic Model T and the $5-a-day wage he offered employees established Detroit as a place where both innovation and high pay were plentiful.

Yet Ford was not content to limit his attentions to automobile manufacturing. While building his company, he acquired a strange array of political beliefs, some of which seemed contradictory. Despite being a self-proclaimed pacifist and publicly supporting Pres. Woodrow Wilson's desire to establish the League of Nations, Ford nonetheless supplied arms to Great Britain and the United States during World War I. While living on Edison Street during the second decade of the 20th century, Ford made friends with neighbor Rabbi Leo Franklin of Temple Beth El. The two were frequent guests in each other's homes, yet during the 1920s, Ford owned the *Dearborn Independent,* which ran a series of rabidly anti-Semitic articles that shocked and saddened Franklin. Ford later apologized to the Jewish community, but the damage had been done. The notoriety from the paper earned Ford the admiration of Adolph Hitler. In fact, Ford is the only American singled out for praise in Hitler's *Mein Kampf.*

In 1906, George Gough Booth succeeded father-in-law James Scripps as publisher of the *Detroit News* and chief executive officer of its parent corporation, the Evening News Association. Beyond being just a newspaper executive, Booth harbored a deep love for art and architecture, especially the style of the Arts and Crafts movement. In 1904, he purchased a farm in Bloomfield Hills, a northern suburb of Detroit, to serve as his country estate. After commissioning noted architect Albert Kahn to design his home, he embarked on a lifelong dream of establishing an academic community with an emphasis on art and design. Over the next several decades, he established an elementary school; separate high schools for girls and boys; and (his crowning achievement) the Cranbrook Academy of Art, a graduate institution that operates under the European-style apprenticeship model. Students work under the tutelage of a

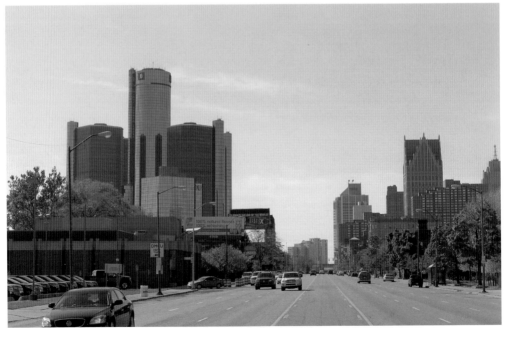

The impressive skyline of downtown Detroit greets visitors arriving along East Jefferson Avenue. (Courtesy of the author.)

faculty mentor for their complete graduate career on a directed-study basis. Today, Cranbrook remains one of the nation's most prestigious centers of art-and-design education.

Orville Hubbard was the mayor of suburban Dearborn from 1942 until 1978. Even today, he remains one of the most controversial figures in Michigan political history. For more than three decades, his populist appeal and folksy charm, along with his machine-style politics, made him virtually invincible at the polls. Burgeoning tax revenues, contributed largely by Ford Motor Company, enabled Hubbard to offer an extravagant array of city services—including babysitting, snow shoveling, numerous well-maintained parks, and even a summer camp outside the city limits and a senior citizen apartment tower in Florida—all for the exclusive use of Dearborn residents.

But the policy for which Hubbard was most well known was his notorious passion for racial segregation. Despite sharing a lengthy border with Detroit, Dearborn remained virtually all white throughout Hubbard's tenure. Black families attempting to move to the city were greeted with police and fire personnel awaking them at all hours of the night, asking about some imaginary emergency. Hubbard is still regarded as a larger than life figure in Dearborn—literally. A 10-foot-high statue of the mayor occupies the front lawn of city hall, along with a historical marker that makes no mention of his segregationist past. Today, more enlightened residents are working to create a more tolerant image for their city.

Coleman Young's election as Detroit's first African American mayor in 1973 was a reflection of the city's changing racial and social demographics. In response to increasing levels of crime, the leadership of the police department—still overwhelmingly white—implemented an undercover decoy unit called STRESS (and acronym standing for Stop The Robberies Enjoy Safe Streets). STRESS was known for its brutal tactics, targeting African American males by the now discredited method of racial profiling. Over its two-year life, STRESS gained a notorious reputation. Author William Rich wrote, "During a thirty-month period in the early 1970s, there were an estimated 400 warrantless police raids and 22 related deaths (mostly of blacks). Detroit had the highest number of civilian killings per capita of any American police force."

The campus of Cranbrook in Bloomfield Hills provides an oasis of exquisite beauty. (Courtesy of the author.)

The abuse became so pronounced that it emerged as a major issue in the mayoral election of 1973. During the campaign, Young pledged to abolish STRESS if elected. His opponent was former police commissioner John Nichols, running on a pro-STRESS platform. Young's historic victory began a career that would last a full five terms and make him the longest-serving chief executive in Detroit's history. As his tenure progressed, however, it became clear that, while African Americans were gaining political power, they were failing to advance economically. The city's population and jobs steadily decreased during the 1970s and 1980s, while crime and poverty increased. As a result, Young's legacy is a mixed one.

Dave Bing, who won a special mayoral election in 2009 to serve the remaining portion of former mayor Kwame Kilpatrick's second term, is currently near the completion of his first full term. Kilpatrick resigned as part of a plea deal after being charged with perjury and obstruction of justice in the infamous text-message scandal, when the mayor lied under oath during a police whistle-blower lawsuit. Kilpatrick testified that he and his chief of staff, Christine Beatty, were not having an extramarital affair, a claim contradicted by the messages they exchanged on their city-issued pagers. Bing, a former NBA player and business entrepreneur, was faced with the unenviable task of restoring confidence in a city hall long tainted by corruption, shoring up Detroit's ailing finances, and attacking the ongoing problems of increasing crime and declining population. Bing is also the first Detroit mayor forced to work under a state-appointed Emergency Financial Manager. Despite the enormity of the challenges, the mayor has confronted them with energy and optimism.

Dan Gilbert is the type of spirited businessperson whose work sparks a can-do approach to Detroit's future. In 2010, he began moving his mortgage business, Quicken Loans, and its thousands of employees from the suburbs to the central business district. Soon after, he went on a buying binge of downtown real estate, renovating the classic structures and leasing them to a plethora of high tech businesses, many of which are components of Detroit Venture Partners, his umbrella company. Collectively, all this activity has transformed the culture and the pace of downtown Detroit. Thanks to his bullish view of the future, the welcome sight of new restaurants, bars, coffee shops, and pedestrians has inspired a new optimism.

CHAPTER ONE

Firsts

If the 20th century can be viewed as the "American Century," Detroit's influence is a major reason why. The population growth the city experienced after 1900 was largely the result of new arrivals from Italy, Poland, Canada, and the American South, both black and white. Most of these newcomers sought jobs in the automobile industry, but others provided the city with the human infrastructure needed to support a growing community. The families that arrived produced this next generation of Detroit's doctors, lawyers, architects, and entrepreneurs whose innovations and contributions were felt locally, nationally, and even internationally.

Some of these pioneers were unsung heroes who advanced the causes of civil rights, often at risk to their own safety. By his courage, physician Ossian Sweet provided an example of breaking down the walls of segregation in the face of vigorous resistance. By doing so, he helped pave the way for all citizens to participate fully in Detroit's civic and cultural life.

Years later, Mary Beck and Jennifer Granholm accomplished the same breakthrough for Michigan women, becoming the first female member of Detroit Common Council and the first female governor of Michigan, respectively.

These milestones serve as testimonies to the human ability to evolve socially—to adopt enlightened social mores that recognize the equality of all people and value the unique contributions of each person.

Detroit Gets Its Wheels

Contrary to popular belief, Henry Ford invented neither the automobile or the assembly line. He was not even the first to drive a "horseless carriage" on the streets of Detroit. Charles King (seated on the right), a California-born engineer who arrived in the city in 1889, was Detroit's earliest automobile pioneer but saw himself as Ford's confidant, not his rival. While working as a draftsman at the Michigan Car Company (a manufacturer of railroad cars), King visited the World's Columbian Exposition in Chicago in 1903 and was intrigued by the early cars shown by Gottlieb Daimler and the Duryea brothers, prompting him to tinker with internal combustion engines in his spare time. On March 7, 1896, at 11:00 p.m., King made his historic drive up Woodward Avenue, a Detroit automotive first. His friendship with Henry Ford endured, as seen below in a 1946 image of (from left to right) King, Ransom Olds, and Ford.

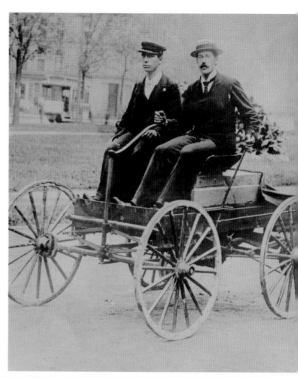

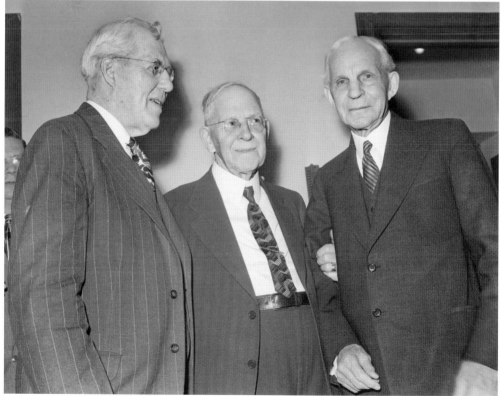

Another Automotive First

Ed Davis was a businessperson who used his acumen not only for self-enrichment but also for leveling the racial playing field in the world of automotive retailing. A native of Shreveport, Louisiana, Davis migrated north at the young age of 15 to attend Cass Technical High School with the goal of becoming an accountant. After graduation, however, he discovered that few opportunities existed for African Americans in the profession. Turning to his second interest, automobiles, Davis rented a service bay in a gas station to offer car-washing services. A chance meeting with a supervisor at the Dodge Main factory led to a succession of jobs there, followed by a part-time sales position at a Chrysler-Plymouth dealership. Thus, Davis became the first African American automobile salesman in Detroit. In 1936, however, the entrenched racism of the time forbade him to work on the sales floor, and he was forced to operate from a makeshift office in a second-floor storage room. He used the limitation to his advantage, harnessing his connections with various black community leaders, and word quickly spread about the "black man selling Chryslers." Davis's business prospered. In 1939, he struck out on his own, opening Davis Motor Sales, a used-car dealership on East Vernor Highway in the city's historically black Paradise Valley neighborhood. His success continued, and in 1940 he was approached by Studebaker and offered a new car franchise, the first such offer to an African American by any automaker. By 1954, Studebaker sales began to falter, and the company was sold to Packard. Yet the combined company was unable to compete, and its ensuing bankruptcy spelled the end of Davis's franchise. A stint in sales with a Ford dealership was followed by the crowning achievement of his career: becoming the first African American to be granted a Big Three franchise with the opening of Ed Davis Chrysler in 1963. Located on the west side at Dexter and Elmhurst, the business's first several years were hugely successful, attracting both black and white car buyers. Sadly, however, the years after the 1967 insurrection led to a decline, and Davis closed his store and retired in 1971.

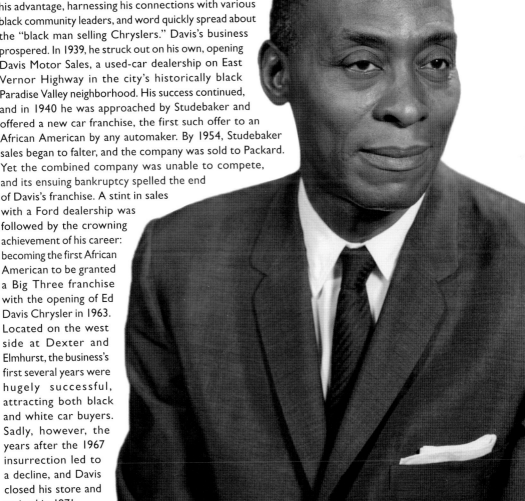

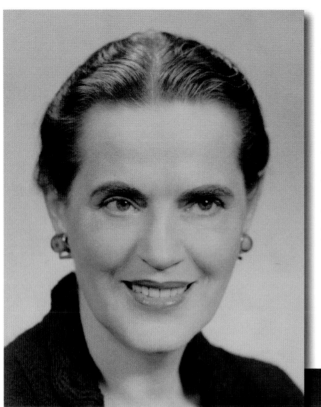

Mary Beck

People who have been a first at anything are often thought of as mavericks or rabble-rousers. Mary Beck was no exception. Born Mary Woytowych in Ford City, Pennsylvania, in 1908, Beck was educated as a social worker and lawyer and was admitted to the Michigan Bar in 1944. In 1950, after practicing law for a few years, she became the first woman elected to what was then called the Detroit Common Council. She almost scored another first in 1969 when she threw her hat into the mayoral race. Her campaign slogan, "Sweep the Deck with Mary Beck," demonstrated her progressive bent. (Courtesy of the Michigan Women's Hall of Fame.)

Michigan's First Female Governor

Jennifer Granholm was elected Michigan's first female governor in 2002, the culmination of a successful political career that also included posts as an assistant US attorney, as Wayne County Corporation Counsel, and as Michigan attorney general. A native of Vancouver, British Columbia, Jennifer moved to the United States at the age of four and graduated from San Carlos High School in 1977. After abandoning her goal of a career in entertainment, Granholm attended the University of California at Berkeley and Harvard Law School. Marriage brought her to Michigan. During her governorship, Michigan was confronted with daunting challenges including unemployment and a declining tax base. Creative leadership led to the arrival of new industries, such as clean energy, life sciences, and automotive battery research. (Courtesy of the Michigan Women's Hall of Fame.)

A Monumental Step Toward Justice

Surprising as it may sound, segregation in schools was common beyond the American South prior to the Civil War. In 1867, the Michigan Legislature passed Public Act 34, which outlawed the racial segregation of schools in the state. The implementation of the law was slow, however, and in 1869 Fannie Richards, a teacher at Detroit Colored School No. 2 and the city's first African American educator, was overjoyed to hear that it had been upheld by the Michigan Supreme Court. The case *Workman v. Detroit Board of Education* essentially became the Northern counterpart to *Brown v. Board of Education*. Born into a free black family in Virginia in 1840, Richards moved to Detroit at a young age. After finishing school, she continued her education in Toronto and returned to Detroit to begin her career as a teacher. Following the court ruling, she began a 44-year career at Everett School, where she established the city's first kindergarten program. (Courtesy of the Burton Historical Collection, Detroit Public Library.)

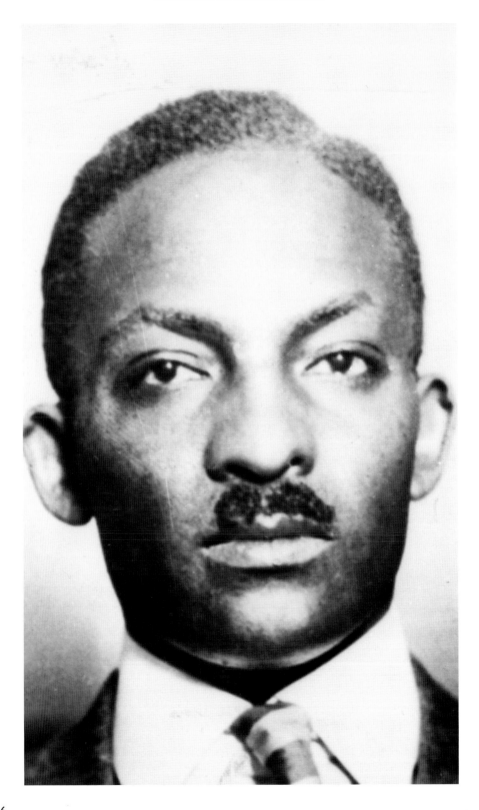

A Reluctant Warrior

While growing up in the South, Ossian Sweet never imagined he would one day be revered as a civil rights icon. In 1908, when he was 13 years old, his parents (who were former slaves) sent him from Bartow, Florida, to Wilberforce University in Xenia, Ohio, to attend preparatory school and college. Diligently striving to meet the rigorous demands of his studies, Sweet also worked odd jobs to finance his education. After his baccalaureate education, he attended medical school at Howard University and achieved his personal goal of becoming a physician. Sweet arrived in Detroit in 1921 and married Gladys Mitchell the following year. His success serving the African American community allowed him to move his family from the crowded Black Bottom area just east of downtown to a pleasant middle-class neighborhood on the lower east side. While concerned about possible violence, he also felt that, as an American, he had the right to live in any area within his means. After finding a realtor who would work with a black client and a bank willing to provide financing (both of which proved very difficult), Ossian Sweet and his wife closed on a modest bungalow at the corner of Garland and Charlevoix Streets in the Waterworks Park neighborhood in September 1925. For two nights, a white mob gathered outside the home, occasionally pelting it with rocks. To defend his domicile, Sweet enlisted the help of several armed men, including two of his brothers. During a particularly tense moment, a shot rang out from the second floor of the house, striking and killing a man standing across the street. Everyone inside the house was arrested and charged with murder. The Detroit NAACP saw the case as a test of the cause of civil rights, which was just beginning to stir the public conscience, and aided in the defense by paying the famed attorney Clarence Darrow to represent the accused. As the cases moved to trial, charges against a few of the defendants were dropped, while the jury deadlocked on the others. A mistrial was declared, and Ossian Sweet's place in history was sealed. (Opposite page, courtesy of the Walter Reuther Library; above, courtesy of the author.)

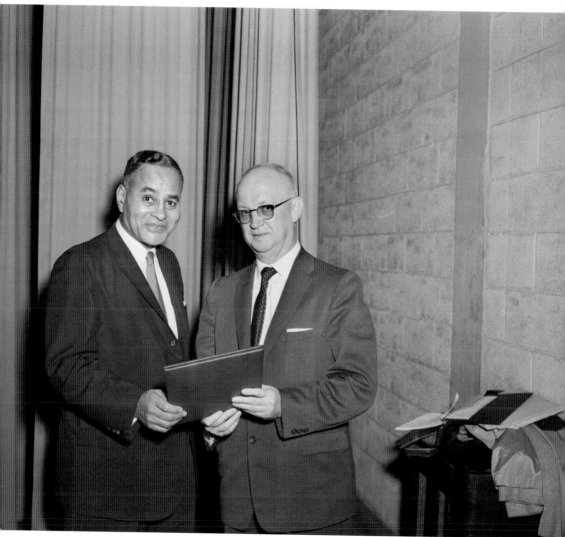

A Believer in Hope

Dr. Ralph Bunche's life was a testament to the power of education and enlightenment to change hearts—and the world. Born in Detroit in 1904 and raised in Los Angeles, he graduated summa cum laude from the University of California, Los Angeles (UCLA) in 1927. After completing graduate studies in political science at Harvard, Bunche embarked on a storied career in academia and public service, including tenure at Howard University and a stint with the Office of Strategic Services (OSS), the forerunner to the CIA. His greatest achievement, however, was his contribution to the formation of the United Nations, particularly his involvement in the Dumbarton Oaks Conference in 1944 and the Arab-Israeli Armistice in 1949. In 1950, Bunche became the first person of color to be awarded the Nobel Peace Prize.

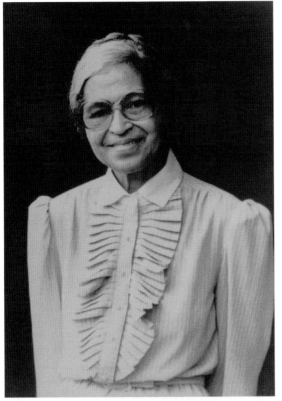

A Detroit, and American, Icon

The name Rosa Parks immediately brings to mind the struggle for justice and an end to the discriminatory laws of the Jim Crow era. After her historic 1955 stand against segregation in Montgomery, Alabama, Parks's life remained mired in difficulties. Shortly after the historic bus boycott, she was dismissed from her job, prompting her to move with her husband to Detroit in 1957. After briefly returning to the tailoring profession, Parks joined the staff of congressman John Conyers. After retiring, she and her friend Elaine Eason Steele established the Rosa & Raymond Parks Institute for Self Development, an educational resource for at-risk youth. Today, the famous bus, now restored, resides at the Henry Ford Museum in Dearborn. (Left, courtesy of the Michigan Women's Hall of Fame; below, courtesy of The Henry Ford.)

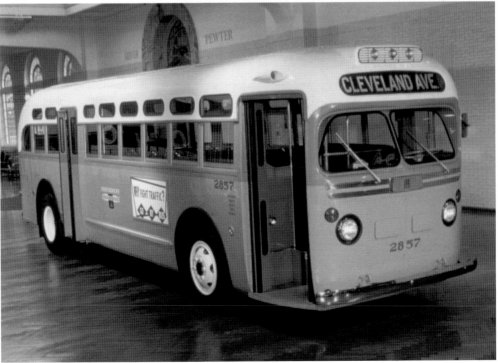

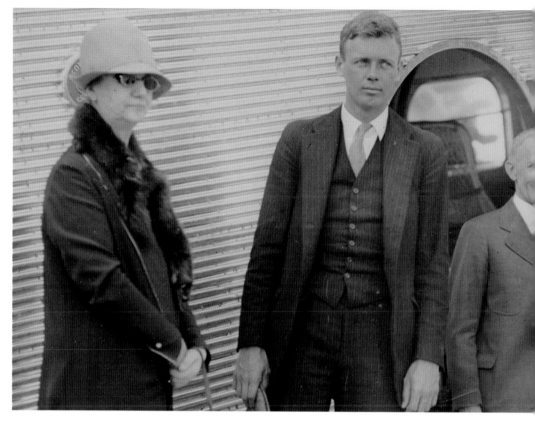

An Accomplished but Controversial Life

Charles Lindbergh is an individual who represents a Detroit connection to the international stage. His noteworthy achievements in aviation, coupled with his questionable political loyalties, make him one of the most puzzling figures of the 20th century. Lindbergh was born in Detroit in 1902 but as a child moved with his family to Little Falls, Minnesota, where he was raised. Showing mechanical aptitude at an early age, Lindbergh abandoned his college studies after two years to fly planes in air shows, where he performed breathtaking stunts. Enlisting in the US Army Air Corps Reserve in 1924, he obtained fight training in Texas and was regarded as the most skilled pilot in his class. In 1927, Lindbergh decided to compete for a $25,000 prize offered by New York hotelier Raymond Orteig to the first aviator to complete a nonstop, solo flight from New York to Paris. Enlisting investors from St. Louis, Lindbergh designed a plane to his specifications, including a large-capacity gas tank. On May 20, he took off from Roosevelt Island, New York, and successfully landed in Paris 33.5 hours later. Upon his return to the United States, he was honored with a Detroit parade along Woodward Avenue, where he rode atop an open-air car with his mother and great uncle, former Detroit mayor John Lodge (pictured above). Upon his return to the United States, Lindbergh was honored by a parade along Woodward Avenue. But the aura of Lindbergh's accomplishment soon faded. Following the tragic kidnapping and murder of his son in 1932, excessive hounding by the media forced him to move his family to England, where he lived until 1935. While there, he was invited by the governments of France and Germany (with the tacit approval of the US War Department) to inspect their military air corps. He wrote that he was extremely impressed with German *Luftwaffe* (air force). He was subsequently presented with the Order of the German Eagle by the Nazi regime. Incurring the wrath of many Americans, Lindbergh returned to the United States and soon became affiliated with the growing isolationist movement. These facts, along with the anti-Semitic tone of his prolific writings, made him an extremely controversial figure despite his accomplishments. After the attack on Pearl Harbor, his petition to have his military commission reinstated was denied by the Roosevelt administration. Scholars continue to debate his legacy today.

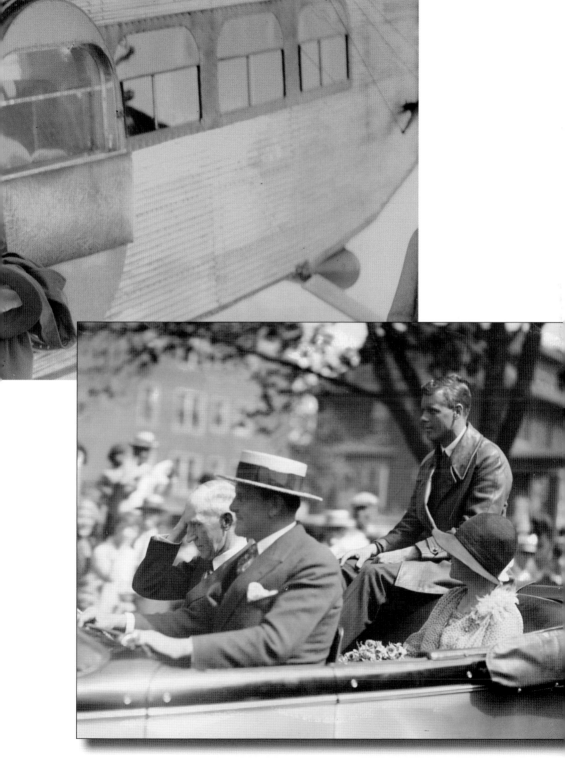

A Long-Standing Barrier Broken
No survey of 20th-century Detroit firsts would be complete without a mention of Coleman Alexander Young. Young was born in 1918 in Tuscaloosa, Alabama, and moved to Detroit with his family during his youth. Throughout his entire life, he was a passionate advocate for social justice and an enemy of racism. During World War II, Young was assigned to the 477th Medium-Bomber Group based in Tuskegee, Alabama. The 477th was a unit of the famous Tuskegee Airmen, the first group of black airmen. Elected Detroit's first African American mayor in 1973, Young left a mixed record of accomplishments and missed opportunities; he brought needed reform to the police department but was unable to stem the city's economic decline. He is pictured here with his immediate predecessor, Roman Gribbs.

CHAPTER TWO

In the Public Square

What motivates a woman or man to commit to a life of public service? Such a life invariably requires forfeiting one's privacy and enduring the constant judgment of strangers. However, despite these (and other) sacrifices, working for the betterment of society also brings with it certain rewards.

When considering the reasons people seek public office, a look at human nature would seem to reveal two possible motivations—a desire on the part of fortunate individuals to give back out of gratitude for their blessings or a vain quest for personal glory. Sometimes, the catalyst can be a curious combination of the two.

But when an individual or group outside the political arena leaves an unexpected mark on society, sometimes at great personal cost, the results can be truly heroic. Viola Liuzzo certainly did not plan on dying while crusading for voters' rights in 1965. Walter Reuther knew the possible risk to his own safety while working to have Ford recognize the UAW but did not expect to be brutalized.

Individuals of such vision and courage should awaken all to the human potential for good and inspire others to imitation.

Michigan's Teddy Roosevelt

History often pivots on the contributions of unusual, or even eccentric, individuals. Hazen Pingree, mayor of Detroit from 1889 to 1897 and governor of Michigan from 1897 to 1901, serves as a compelling example. Born in Denmark, Maine, in 1840, Pingree enlisted in the Union army in 1862 and served with the 1st Massachusetts Heavy Artillery Regiment. Seeing action in various campaigns, he was captured in May 1864 and served time in various Confederate prison camps. He made a daring escape by assuming another soldier's identity during a prisoner exchange. After the war, Pingree moved to Detroit and resumed work in his pre-war occupation as a cobbler. Prodded by friends to enter politics, he ran for mayor in 1889 as a Republican. At the time, city hall was riddled with corruption, and the reformist Pingree successfully unseated incumbent John Pridgeon. Detroit was ill prepared for the approaching 20th century, and inadequate roads, poor public lighting, and exorbitant utility and telephone rates irritated the public. Holding true to his campaign promises, Republican Pingree responded in a way characteristic of modern Democrats—through activist government intervention. In 1895, the Public Lighting Commission was created, consolidating and improving upon a patchwork of privately operated systems. Pingree was given to bombastic attacks on cooperationists, and often, the veracity of his outbursts alone would persuade his targets to lower either natural gas or telephone rates. His greatest battle, however, was with the five streetcar companies that served various areas of the city. The mayor launched a tireless battle to bring the system, which charged excessively high fares and ran on uncoordinated schedules, under city control. Eventually, the companies merged to form Detroit United Railway, which would later be sold to the city to form the Department of Street Railways (DSR) in 1915. Hazen Pingree went on to serve four years as Michigan's governor, during which time he advocated for popular election of US senators (this would eventually be accomplished with ratification of the 17th Amendment in 1912). He died in London on June 18, 1901, following a trip to Africa.

A Midcentury Progressive

Born to American parents in a Mormon colony in Mexico in 1907, George Romney overcame overwhelming hardships as a youngster to achieve success as a missionary in Great Britain, as a salesman for a large aluminum company, and later as a Washington lobbyist for the Automobile Manufacturers Association. After serving as chairman of American Motors Corporation during the 1950s, he entered the public sphere, first as a member of the Michigan Constitutional Convention and later as governor. While the state's chief executive, Romney provided steady leadership during the 1967 Detroit insurrection, successfully procuring federal troops to restore order. Romney also supported the civil rights movement, a rarity for Republicans during the 1960s.

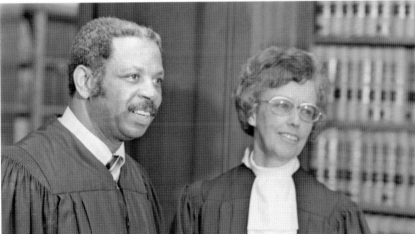

A Judge for All People

The life of Damon Keith (left) was characterized by dogged persistence and devotion to racial and economic justice. Keith was born in Detroit in 1922. At the time, because discrimination prevented blacks from rising to positions of power and influence, youngsters like Damon were presented with few role models. Drawing inspiration from his hardworking father, the younger Keith attended West Virginia State College and Howard University before returning to Detroit to practice law. The demeaning attitudes of many white judges created no bitterness in Keith but made him resolve to treat all people with courtesy and dignity if he ever assumed a position of authority. In 1967, he was appointed by Pres. Lyndon Johnson to the federal district bench in Detroit. Ten years later, he was named to the Circuit Court of Appeals for the Sixth Circuit by Pres. Jimmy Carter. Throughout his career, Keith never cited a single individual for contempt.

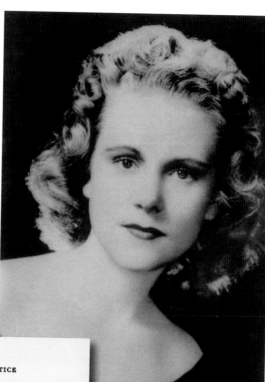

A Martyr for Justice

On March 7, 1965, Viola Liuzzo watched the developments in Selma, Alabama, with horror. Civil rights advocates marching for an end to the disenfranchisement of blacks were brutally beaten by state troopers as they crossed the Edmund Pettus Bridge. The 39-year-old mother and Wayne State University student traveled south to offer her help. After the group's third and final march (which accomplished its ultimate goal), Liuzzo was driving marchers back to Selma when she was shot and killed by members of the Ku Klux Klan. Her death sparked an FBI investigation and influenced the passage of the Voting Rights Act later that year.

UNITED STATES DEPARTMENT OF JUSTICE

FEDERAL BUREAU OF INVESTIGATION

In Reply, Please Refer to
File No.

Chicago, Illinois
April 5, 1965

SILENT VIGIL IN HONOR OF
MRS. VIOLA LIUZZO, CITY
HALL, EVANSTON, ILLINOIS,
APRIL 3, 1965
RACIAL MATTERS

advised the Federal Bureau of Investigation (FBI), Chicago, Illinois, on April 2, 1965, that a one hour vigil in honor of Mrs. Viola Liuzzo, recently killed in Alabama following the Selma to Montgomery, Alabama civil rights march, will be held on the stairs of the City Hall, Evanston, Illinois, at 1:00 PM, April 3, 1965. This vigil will be sponsored by the North Suburban Coordinating Council, Reverend Emery G. Davis, Chairman. No incidents are expected.

On April 2, 1965, Region I, 113th INTC Group, Chicago, Illinois, was advised of the above information.

Assistant Special Agent in Charge Maurice Martineau, United States Secret Service, Chicago, Illinois, was advised of the above information on April 2, 1965.

advised the FBI, Chicago, Illinois, April 3, 1965, that the silent vigil in honor of Mrs. Viola Liuzzo was held this date at the site of the World War II Memorial at Orrington and Davis Streets near downtown Evanston, Illinois, and not at the Evanston City Hall as planned. This vigil which was sponsored by the North Suburban Coordinating Council was attended by approximately 80 people and lasted from approximately 1:00 PM until 2:00 PM, April 3, 1965. There were no incidents.

157-6-7-1278

ENCLOSURE

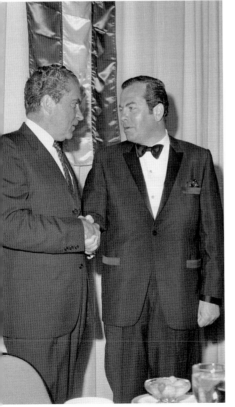

Gerhard Mennen "Soapy" Williams

This liberal lion of Michigan's political establishment enjoyed a career that extended from the late 1940s until 1987. As governor from 1949 to 1961 and as a state supreme court justice from 1970 to 1987, Williams (left) was viewed as a larger-than-life figure overseeing the construction of the Mackinac Bridge, upgrading Michigan's school system, and advocating early for civil rights. He was known for his trademark polka-dot bow tie and for his affectionate nickname, a reference to his status as an heir to the Mennen Company, which made men's grooming products.

A Transitional Mayor

Jerome Cavanagh's victory as mayor of Detroit in 1961 represented the first impact of the city's African American community on a major election. His stunning upset over incumbent Louis Miriani and the optimism of the time (which coincided with the administration of John F. Kennedy) presented Detroit as a national model of positive race relations. Yet underneath the surface, tensions were brewing. The steady exodus of automobile plants and white residents to the suburbs increased poverty in Detroit and triggered the 1967 insurrection. With his reputation tarnished, Cavanagh did not seek reelection in 1969, returning instead to private law practice. He died 10 years later of a heart attack. Cavanagh (right) is pictured here with Pres. Richard Nixon.

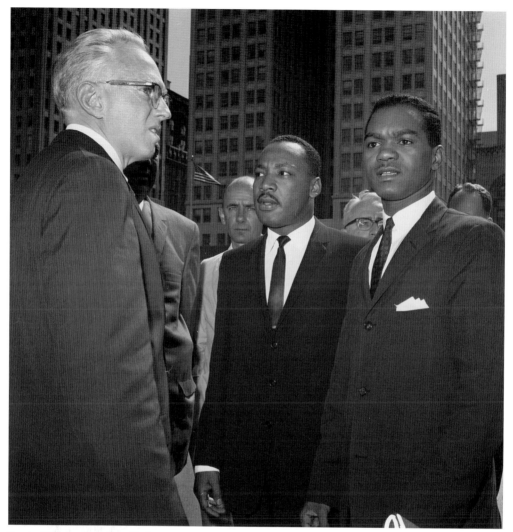

Early Efforts at Police Reform

George Clifton Edwards (left), like G. Mennen Williams, was one of Detroit's early advocates for civil rights. As a member of Detroit Common Council during much of the 1940s, Edwards sought to defuse the growing racial tension surrounding housing integration. After losing the 1949 mayoral election to Albert Cobo on this issue, Edwards later served as a probate, then circuit court judge, before being appointed to the Michigan Supreme Court by Williams. He left the court in 1962 to become Detroit's police commissioner and tried to implement reforms to curb police brutality and increase the number of black officers. In 1963, he marched with Martin Luther King Jr. down Woodward Avenue during the Great March on Detroit.

Breaking Barriers—Quietly

At a time when the civil rights movement was often associated with radical elements in American society, Dr. Arthur Johnson's efforts to bridge this gap provided the city with a lasting legacy. Johnson, a native of Americus, Georgia, was educated at Morehouse and Atlanta Universities. His career initially involved work with the NAACP, which sent him to Detroit in 1950 to become executive secretary of its Detroit branch. After 14 years in the post, he became an administrator for the Detroit Public Schools and later worked in administration for Wayne State University and the Detroit Symphony Orchestra (DSO). He also organized the Freedom Fund Dinner for the NAACP, encouraged the adoption of music by African American composers at the DSO, and introduced the Detroit Festival of the Arts. He was a proud participant in Dr. Martin Luther King Jr.'s 1963 March on Detroit.

Jimmy Hoffa

In 1975, bumper stickers began appearing in Detroit and around the nation with the message, "Where's Jimmy Hoffa," followed by a phone number for leaving anonymous tips. A storied American mystery, guessing the whereabouts of the missing labor leader remains a popular parlor game. Hoffa arrived in Detroit in 1924 as a child. Quitting school at age 14, he began work on a grocery store receiving dock, where he successfully organized the staff and ended many abusive practices by management. Soon after, he turned to organizing full time with the relatively young Teamsters, a union that concentrated on the trucking industry. He devoted almost his whole life to the cause, building the Teamsters into one of the most formidable unions in America. But union organizing during the Depression era was a brutal business, and violent altercations with police, employer-hired security personnel, and rival unions were commonplace. This only served to inflame Hoffa's passion, though, and he made the establishment of a nationwide truckers' union his personal mission. Over time, he made legally questionable alliances with organized crime figures, spawning a level of

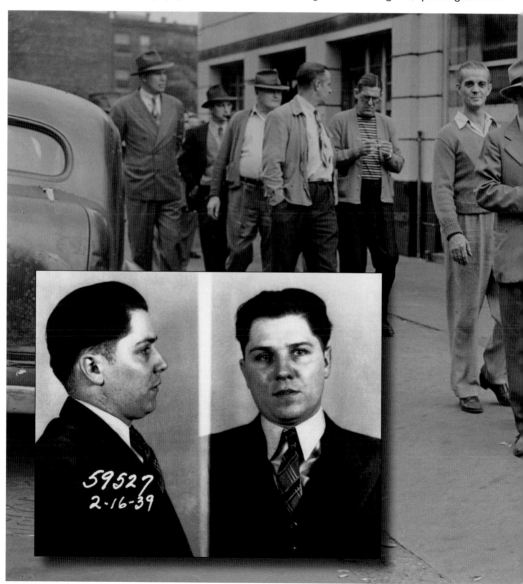

corruption that caused the Teamsters to be expelled from the American Federation of Labor and Congress of Industrial Organizations in 1957, shortly before Hoffa was elected Teamsters president. In the early 1960s, his activities attracted the attention of attorney general Robert Kennedy, who pursued him doggedly. He was sent to prison in 1967 for jury tampering and other charges, but his sentence was commuted to time served by Pres. Richard Nixon in 1971, provided he abstain from union involvement until 1980. Hoffa bristled at this restriction and was preparing a legal means of circumventing it. On July 31, 1975, Hoffa left for a lunch meeting with Anthony Provenzano and Anthony Giacalone, two New Jersey Teamster figures, at the Machus Red Fox restaurant in suburban Bloomfield Hills. He was never seen again, and Provenzano and Giacalone later claimed to have no knowledge of such a meeting. Hoffa was proclaimed legally dead in 1982, though his body was never found. Occasionally, the FBI makes public tips they receive regarding the location of his burial spot, none of which have proven accurate. (Below, courtesy of Walter Reuther Library; inset, courtesy of Scott Burnstein.)

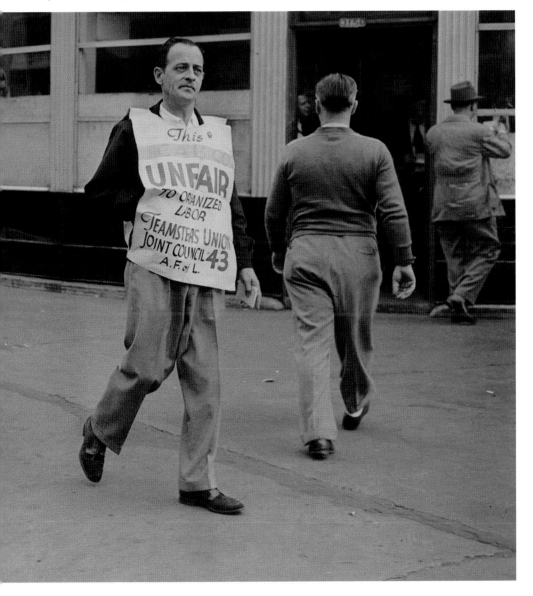

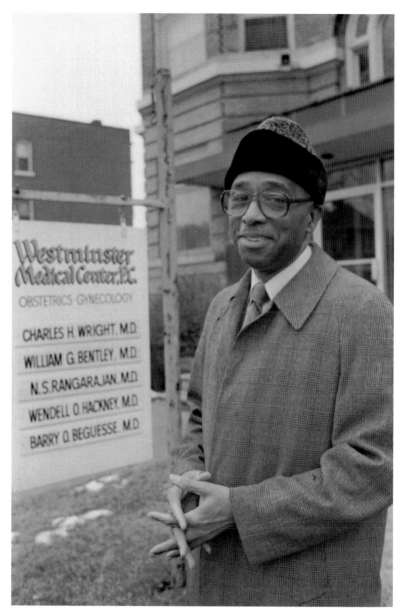

A Pioneer in Two Fields

Dr. Charles H. Wright was equally devoted to two passions: serving his patients with courtesy and dignity and working to integrate Detroit's medical facilities. A native of Dotham, Alabama, Dr. Wright attended segregated schools as a youngster and went on to earn his degrees from local, historically black colleges. After performing his residency in Harlem, he practiced general medicine in Detroit until 1950, when he was able to return to New York to complete a graduate residency in obstetrics and gynecology, his chosen specialty. Returning to Detroit, he successfully pressured political leaders to integrate the Detroit Medical Center. At the same time, he capitalized on his interest in history by establishing the International Afro-American Museum in 1965 to showcase contributions made by African Americans. Today, this first-class institution is located in its third building and has been renamed the Charles H. Wright Museum of African American History.

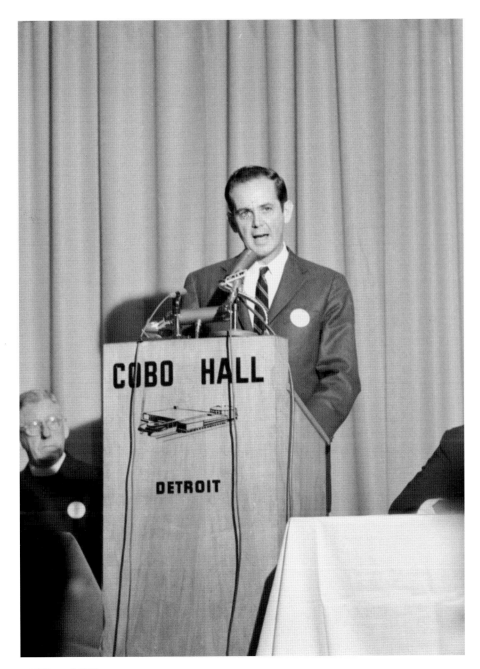

Gov. William Milliken

As the state's chief executive from 1969 until 1983, William Milliken holds the record of Michigan's longest-serving governor. As lieutenant governor under George Romney, Milliken was elevated to the state's top job when Romney was tapped by Pres. Richard Nixon to serve as US Secretary of Housing and Urban Development. Milliken would go on to win three four-year terms. He typified mainstream Republican governance during the 1970s, showing financial restraint and espousing a pro-business philosophy while reflecting a more liberal stance on the various social issues. As the Republicans have trended further to the right in recent years, Milliken has found himself increasingly at odds with his own party.

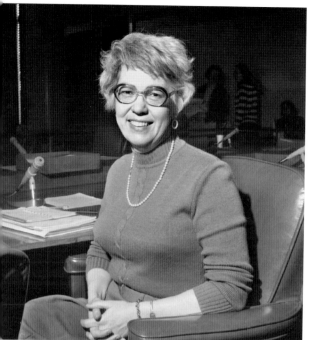

A Strong Voice for All People

Maryann Mahaffey's background as a social worker gave her a sense of compassion and concern seldom seen in public officials. First elected to the Detroit City Council in 1973, her humble nature showed itself in numerous ways. When her northwest Detroit neighborhood began to be integrated, she escorted African American children to school to assure their safety. On council, she tirelessly advocated for the poor and disabled, making strenuous efforts to maintain programs that benefited them. She also championed development of the city's more viable areas and remained eternally optimistic about Detroit's long-term prospects. She retired from council in 2005 and died the following year at age 81.

A Scholar Comes to City Hall

During a career in city government that spanned more than four decades, Mel Ravitz, a sociology professor at Wayne State University, brought a calm demeanor and dispassionate thinking to city council deliberations. Taking office in 1961, Ravitz was acutely aware of the city's changing demographics and promoted what he saw as the necessary ways to confront this new reality. He strongly advocated open housing (at a time when most conservative figures opposed it); a renewed emphasis on improving city services; and, most importantly, an end to racial prejudice—which Ravitz saw as the greatest hindrance to social progress, by far.

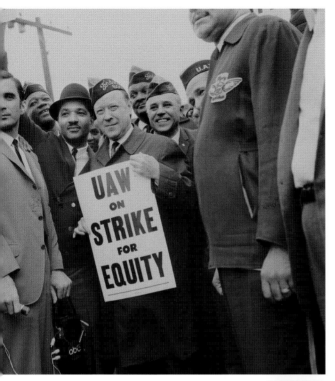

Pioneer in the Labor Movement

Best known as an early figure in organized labor and as an advocate for social justice, Walter Reuther's courageous and persistent efforts to organize the Detroit automobile industry came at great personal cost. On May 26, 1937, Reuther and several deputies were distributing leaflets at the Ford Rouge Plant when they were confronted by Ford security personnel, who beat them savagely. But Ford was unable to keep the union at bay forever, and in 1941, it became the last of the Big Three to recognize the United Auto Workers (UAW). Reuther (pictured holding the sign) died in 1970 in a small plane crash in northern Michigan.

Helen Milliken

Few public figures in Michigan have been as impactful on the lives of women as has Helen Milliken. Prior to becoming Michigan's first lady, she possessed little knowledge of what public life involved. When her husband, William Milliken, became governor, she became dedicated to women's causes at the behest of her daughter, a law student at the University of Michigan. At the time, Congress was about to the pass the Equal Rights Amendment, and Milliken lobbied the Michigan legislature to ratify the measure, which it did in 1972. Milliken also advocated tirelessly for other women's issues, including equal pay and pro-choice legislation. Her leadership symbolized Michigan's role as a truly progressive state.

35

Oakland University's Founder

Matilda Dodge Wilson's life is an example of old-money philanthropy doing an extraordinary amount of good. The heiress of both automotive and lumber fortunes, she commissioned two palatial buildings during the 1920s—the Wilson Theatre in Detroit (now the Music Hall for Performing Arts) and Meadow Brook Hall in Rochester, which boasts an outdoor sculpture garden featuring a statue of Pegasus (at right). In 1957, she and her second husband, Alfred Wilson, bequeathed the manor, 1,400 acres of land, and $2 million in cash for the construction of a satellite campus of Michigan State University. The institution became independent in 1963 and is known today as Oakland University. (Above, courtesy of the Walter Reuther Library; opposite page, both courtesy of the author.)

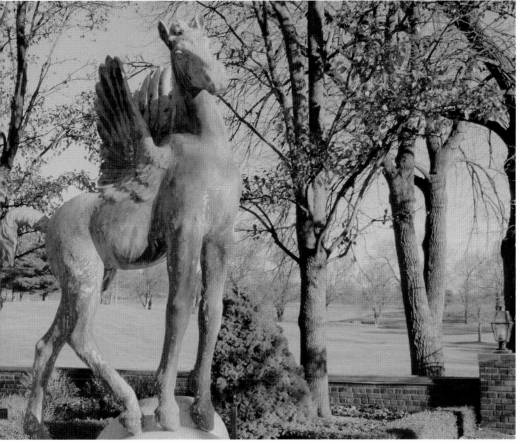

The Little Guy's Advocate

Frank Murphy's (center) lasting imprint on Detroit, Michigan, and on the United States is that of the quintessential well-lived life. Born in 1890 in the town of Sand Beach in the thumb area of Michigan, Murphy attended the University of Michigan for college and law school. After serving as an Army captain in occupied Germany after World War I, he returned to Detroit to work as an assistant US attorney. His caseload was a heavy one, owing to unintended consequences of the Volstead Act, which criminalized hundreds of ordinary Americans by banning alcohol. Despite the overwhelming amount of work, Murphy achieved a 100-percent conviction record. In 1922, he left and began a short-lived stint working in private practice. Elected a judge on the Detroit Recorder's Court in 1923, he continued his storied career of public service. In 1930, he was elected mayor of Detroit in a special election held to replace Charles Bowles, who was recalled after just six months. A strong supporter of Franklin Roosevelt and the New Deal, he was appointed in 1933 to be governor general of the Philippines. In 1935, he became high commissioner of the Philippines, tasked with implementing the Tydings-McDuffie Act, which allowed for the eventual independence of the South Pacific commonwealth. Returning to Michigan, Murphy was elected governor in 1936. His two-year term was a tumultuous one, during which he successfully mediated the 1937 sit-down strike at the General Motors Plant in Flint, resulting in recognition of the United Auto Workers. After his term expired, Murphy was appointed attorney general by President Roosevelt and served in the position for just one year before being elevated to the US Supreme Court. He firmly allied himself with Justice Hugo Black and the rest of the court's liberal wing, writing a strong dissent in *Korematsu v. United States* (which upheld the constitutionality of the World War II–era Japanese internment camps). During the next several years, Murphy's health declined, and he died in 1949 at the age of 59. His rich legacy was honored in 1968 with the construction of the Frank Murphy Hall of Justice.

CHAPTER THREE

Commerce and Industry

If one were to draw a graph depicting Detroit's pace of economic growth over its 300-year-plus history, it would be very lopsided. For the first 200 years or so, the line would just barely edge upward. Upon arriving at the early 20th century, though, its steady climb would arc skyward thanks to the impact of the mass production of the automobile. Within the first three decades of the new century, Detroit was transformed from a modestly sized city known for making stoves, cigars, and pharmaceuticals into an industrial powerhouse of unprecedented proportions.

The automobile was responsible for the rise of the American middle class and even sparked a transformation of the country's physical landscape, spawning superhighways that linked cities and altered the pace of life from a slow, deliberate movement (especially in rural areas) to one that prioritized speed and efficiency.

Automotive manufacturing was, and still is, a highly integrated process involving raw materials, massive transportation networks, suppliers, and dealers—all in addition to the assembly plants themselves. All of this required legions of workers, and Henry Ford's offer of $5 for a day's labor was intended to attract them. The industry produced an exceptionally high standard of living for most Detroiters that was evident to even the most casual observer of the era. Downtown emerged as a luxurious shopping destination, sporting high-end haberdasheries, upscale restaurants, and three major department stores. The largest of these, J.L. Hudson, first opened in 1891 as a men's shop and, over the next 50 years, evolved into a huge, opulent department store covering a full city block with a building of some two million square feet.

In the decades after World War II, Detroit's economy began a long-term decline. Periods of prosperity for the automobile industry occurred only cyclically and were punctuated by progressively severe recessions. New environmental concerns, growing foreign competition, and changing consumer attitudes left their economic scar on Detroit and its environs.

But the dawn of the 21st century has produced renewed hope. Companies specializing in high technology and life science have joined a retooled automobile industry as the foundation for an economic resurgence. Compuware and Quicken Loans are just two examples of this welcome trend, which is a work still in progress.

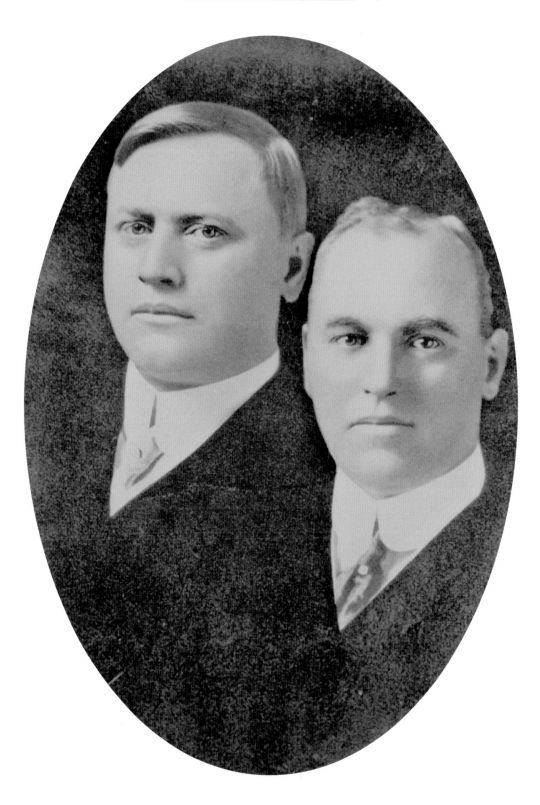

Rags to Riches

The story of John (left) and Horace (right) Dodge is a stunning example of both entrepreneurial achievement and family disaster. Growing up in 19th-century Niles, Michigan, in relative poverty, the brothers (and inseparable friends) moved to Detroit in 1886, looking to profitably utilize their considerable mechanical skills and business acumen. After working as boilermakers and machinists, they started a business producing bicycles. The sold the business in 1900 and next started a machine shop dedicated to producing parts for the burgeoning automobile industry. Their timing proved fortuitous, and soon the company was producing transmissions for Oldsmobile and, later, for the newly chartered Ford Motor Company (in which the brothers were early investors). Delivering products of unparalleled quality produced astonishing success. When Henry Ford offered to buy back their Ford stock in 1919, the Dodges' initial investment of less than $10,000 was valued at as astounding $25 million. Beginning in 1913, the brothers began to produce their own vehicles and built the sprawling Dodge Main plant to assemble them. The cars proved hugely successful, thanks to their sterling reputation for quality. In 1920, John and Horace died within months of each other, both of complications from the Spanish flu. Their widows, Matilda Rausch Dodge (John) and Anna Thompson Dodge (Horace), continued to own the company (which operated through proxy managers) until 1925, when they sold it to New York investment bankers for $146 million in what was, at the time, the largest business transaction in American history. Although both women eventually remarried (Anna Dodge later divorced second husband Hugh Dillman), their inheritance from the sale of the Dodge Brothers, Inc., allowed them to live lifestyles so lavish that they rivaled European royalty. Later passed on to their combined eight children, the money proved to be a family curse. Premature deaths, bankruptcies, and bitter rivalries plagued the next generation of the Dodge family, serving as a reminder of the limits of wealth.

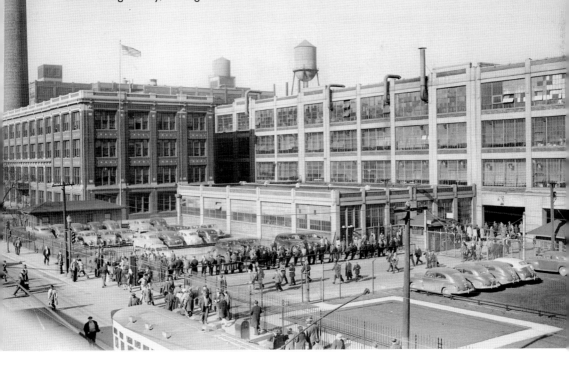

A Family Success Story

Capitalizing on the opportunities of the early automotive era, brothers Fred and Charles Fisher arrived in Detroit from Ohio in 1905 to work in the carriage company established some years earlier by their uncle Albert. While there, they realized that the vibration created by gasoline engines required a radical new design for automotive bodies. The innovations developed by the brothers proved greatly successful, enabling them to purchase a controlling interest in the company and eventually bring each of their five younger brothers into the enterprise. After selling Fisher Body to General Motors in 1919, the brothers commissioned the elegant Fisher Building, "Detroit's largest art object." In the decades that followed, the Fisher family gave generously to the city, donating to dozens of charitable causes. Pictured here are four of the Fisher brothers: (from left to right) Alfred, Edward, William, and Lawrence. (Courtesy of the Walter Reuther Library and of the author.)

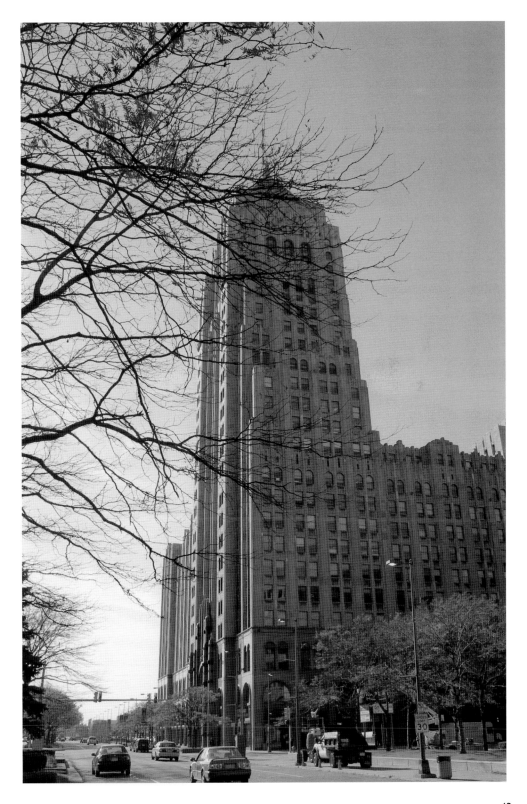

Another Fisher

Max Fisher (no relation to the Fisher brothers) contributed mightily to the Detroit community for more than four decades. A native of Pittsburgh, Fisher came to Detroit at the age of 25 to work in the oil reclamation industry. He eventually started his own company, a distributor of gasoline to retail stations. Realizing tremendous success, he gave back generously to the community, donating to both Jewish and secular charities. Perhaps his most noteworthy project was his fundraising for the Max M. Fisher Music Center, the opulent addition to Orchestra Hall, which provides the Detroit Symphony Orchestra with first-class support facilities. (Right, courtesy of the Walter Reuther Library; below, courtesy of the author.)

The "Engineer" of General Motors

The birth of the automobile industry required both mechanical genius and business acumen. William Durant provided a substantial reserve of the latter, but his over-ambitious tendencies led to his ultimate undoing. Beginning his career as a manufacturer of carriages in pre-automotive Flint, Michigan, in 1886, Durant became general manager of Buick in 1904. In both ventures, he sold product through a system of franchised dealers, a concept that he invented and is still in use today. In 1908, he purchased Cadillac and several smaller automobile companies, organized under the aegis of General Motors Holding Company. Durant also pioneered the concept of separate corporate divisions responsible for major automotive components—a system known as vertical integration.

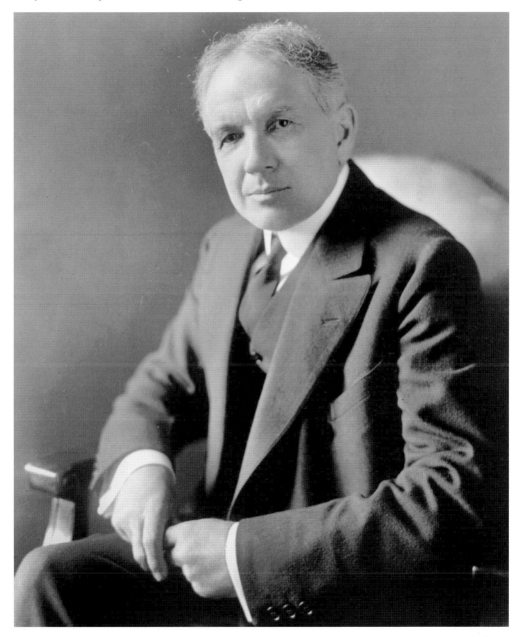

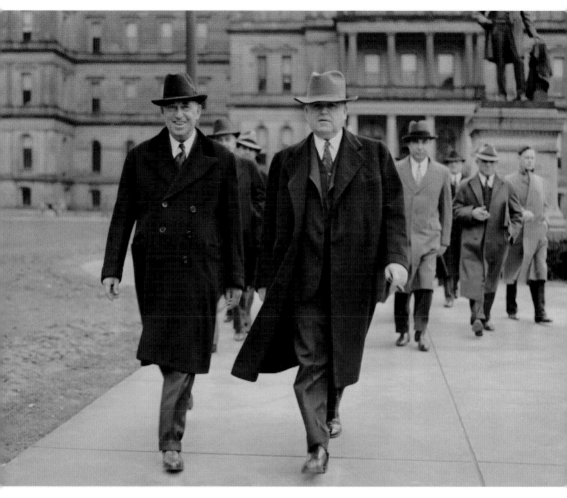

Brains and Financial Brawn

Walter Chrysler (left) never lacked for confidence, a quality he would maximize throughout his successful lifework. After a successful career in the railroad industry, Chrysler was recruited to manage production for Buick Motor Company in 1911. When William Durant returned to General Motors in 1916 (after a six-year exile), he was aware of Chrysler's stellar performance and made an exceedingly generous offer to have him stay. When Chrysler finally left GM in 1919, his stock, which he sold back to the company, was worth more than $10 million. Chrysler went on to form Chrysler Corporation from the Maxwell Motor Company, in which he had acquired a controlling interest. In 1928, Chrysler purchased Dodge, completing what became known as a member of the "Big Three."

Packard Comes to Detroit

Henry Bourne Joy was born in Detroit in 1864, the son of railroad magnate James Joy. Despite his aristocratic background, Joy led an accomplished, productive life. After working in his father's business, he noticed the power and quality of Packard cars while in New York. He persuaded a group of Detroiters to invest in the company, which he encouraged to move north from Warren, Ohio. Joy commissioned Albert Kahn to design the massive Packard plant on East Grand Boulevard, led the company into profitable new markets, and pioneered the Lincoln Highway Association, which undertook the massive task of building a continuous concrete thoroughfare from New York to Los Angeles.

Roy Chapin

Roy Chapin, whose name is little recognized today, had an understated style that contrasted sharply with that of many other automobile pioneers. In 1908, Chapin orchestrated the formation of the Hudson Motors, a new venture intended to compete with Ford, Oldsmobile, and Cadillac. He guided the company—named for department store magnate J.L. Hudson, one of several local businessmen who bankrolled the company (along with Hugh Chalmers, R.B. Jackson, and F.O. Benzer)—to great success in its early years, beginning with the Model 20 Roadster in 1910 and the Phaeton in 1917. Hudson was the first to introduce duel brakes and oil-pressure gauges. Chapin joined the Hoover administration as secretary of commerce in 1932 before returning to Hudson, where he stayed until his death in 1936.

The Real McCoy

Elijah McCoy was born a freeman in Colchester, Ontario, in 1844, the son of escaped slaves from Kentucky. Showing mechanical aptitude, he began studying engineering in Scotland in 1859. After graduating, he settled in Ypsilanti and worked tending engines on the Michigan Central Railroad. Experimenting on new devices during his off time, he invented a device to automatically lubricate railroad engines, eliminating the need to stop. His level of ingenuity led to the creation of other useful items, including the ironing board and the lawn sprinkler. Today, his accomplishments are honored with the phrase "the real McCoy," a reference to a product's durability and usefulness.

Henry Ford: The Baffling Innovator

Known as the quintessential pioneer of American industry, Henry Ford (below, left) is also considered one of the most perplexing Americans of the 20th century, with almost every aspect of his storied life demonstrating odd and contradictory ideals. Ford was born in 1863 and grew up on farm in Greenfield Township (present day Dearborn). He moved to Detroit as a young man and worked at a series of machinist jobs before being hired as an engineer at what was then called Edison Illuminating Company. Experimenting with internal combustion engines during his off hours, Ford designed a series of early cars, which later led to his entry into the automobile-manufacturing business. After two early attempts (one ending in failure and the other with the demand from Ford's partners for his resignation), Ford launched what is known today as Ford Motor Company in 1903 with financial backing from John and Horace Dodge. Ford's business philosophy stressed thrift and efficiency. In 1908, the Model T was introduced with a price of $825, a figure that declined over the ensuing years due to ever-improving production methods.

This phenomenal success permanently altered the physical and cultural landscape of America and elevated Ford to celebrity status nationally and internationally, which in turn revealed his many peculiarities. During

the 1920s, the company was among the first to hire black workers in significant numbers. During this same time, however, Ford also owned a profoundly anti-Semitic newspaper, the *Dearborn Independent*. While Ford's byline accompanied many of the articles, they were written by others, and the extent of Ford's editorial involvement is uncertain. Ford publicly apologized and shut the paper down in 1927, which did little to restore his reputation. Moreover, the depth of his anti-Semitic opinions is well documented, and in 1938 he was awarded the Grand Cross of the German Eagle by the Third Reich. Ironically, however, Ford constructed a plant at Willow Run near Ypsilanti to build B24 Liberator bombers for the US Army Air Force during World War II, which proved essential to the Allied victory. A bitter fight over recognition of the United Auto Workers and the untimely death of his son Edsel in 1943 proved damaging to both Ford on a personal level and to the health of the company. Yet, despite his many shortcomings, Henry Ford's positive contributions to the American economy and way of life cannot be denied. Ford's far-reaching personal connections included a longtime friendship with Thomas Alva Edison (below, right). Today, the second home of Ford Motor Company on Piquette Street operates as an automotive historical museum. (Below, courtesy of the Walter Reuther Library; inset, courtesy of the author.)

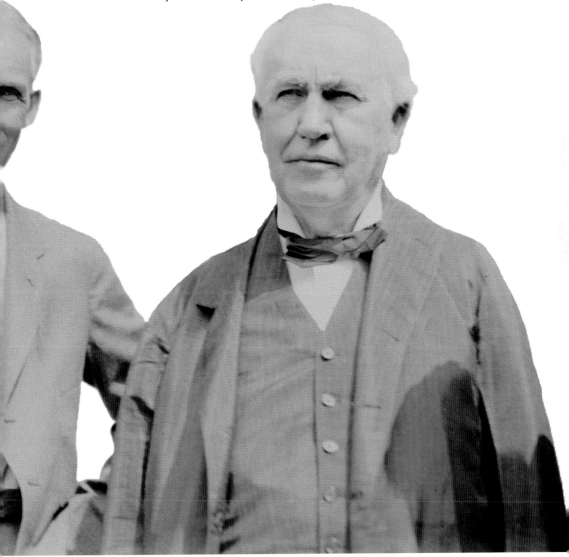

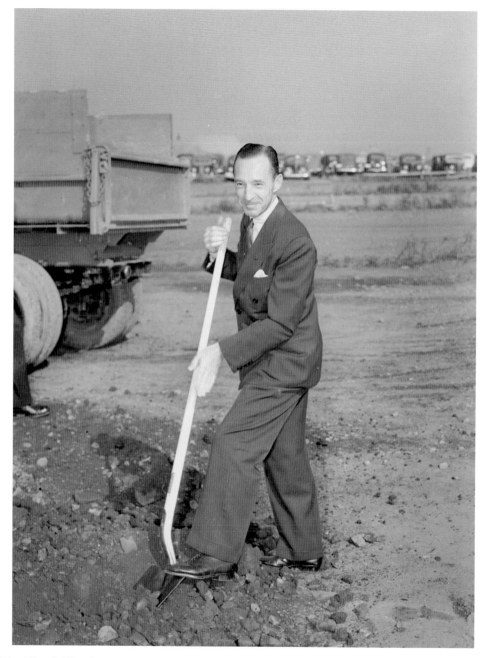

Edsel Ford: The Company's First Stylist

Seldom are a father and son as different from one another as Henry Ford and his son Edsel were. Born in Detroit in 1893, Edsel was the only child of Henry and Clara Bryant Ford. After attending private schools in Lakeville, Connecticut, and Detroit and graduating in 1912, Edsel forwent college to join the family business. He became president of the company in 1919 and emphasized his strong interest in automotive styling, designing the body of the Model A and commissioning custom sports cars. He was also passionate about art collecting and promoting charitable and cultural causes. Unfortunately, Edsel succumbed to stomach cancer in 1943 at the young age of 49.

The Prodigal Grandson

Edsel Ford's untimely death in 1943 rattled Ford Motor Company to its core. To fill the void, an 80-year-old Henry Ford, affected with senility and paranoia, stepped into the presidency. He proved ineffective as an executive, and the company hemorrhaged money, limping along until World War II ended in 1945. At that time, his grandson Henry Ford II, who had been discharged from the US Navy two years earlier, wrested control from the elder Ford with the support of other family members. To rejuvenate the business, he recruited a team of talented engineers, mostly veterans from the Army Air Force. The newcomers, dubbed the "Whiz Kids," conceived new products, streamlined operations, and prepared Ford for the second half of the 20th century. Amazingly, young Henry accomplished this at the tender age of 28.

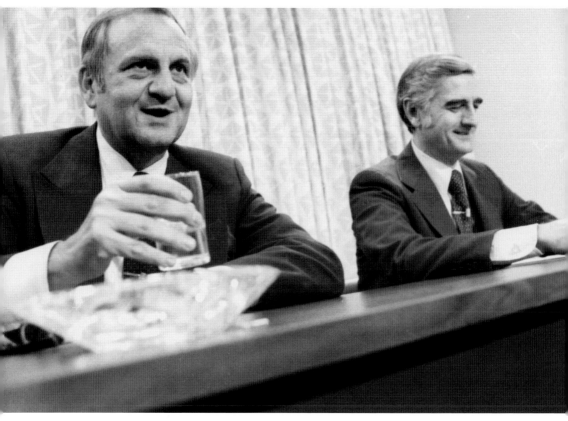

The Hero of Chrysler

Today, Lee Iacocca remains perhaps the best-known and most colorful automobile executive ever. A native of Allentown, Pennsylvania, Iacocca (left) was hired by Ford Motor Company in 1946. Despite his background in engineering, he soon switched to sales, capitalizing on his charismatic personality. Rising through the ranks at Ford, Iacocca was responsible for the iconic Mustang in 1964 as well as the revival of the Mercury brand. After eight years as president, he was abruptly fired by Henry Ford II in 1978. Iacocca moved to the ailing Chrysler and successfully lobbied for $1 billion in government loan guarantees in 1979, which saved the company and vaulted him to celebrity status.

The Era of the Five and Dime (OPPOSITE PAGE)

In 1899, Sebastian Spering Kresge had an idea. With a minimal investment, he and business partner Charles Wilson opened the first two S.S. Kresge discount stores—one in Memphis, Tennessee, and the other in Detroit. Kresge stores would target the working class by offering very inexpensive goods, including household items, work clothes and shoes, candy, and the like. After World War II, the stores would evolve into the popular Kmart brand. Kresge prospered handsomely from his venture, living in a palatial mansion in the Boston Edison district. He was also known as a pillar of the Detroit community for his generous philanthropy through his Kresge Foundation. Today, some 20 libraries and other educational facilities around the nation bear his name.

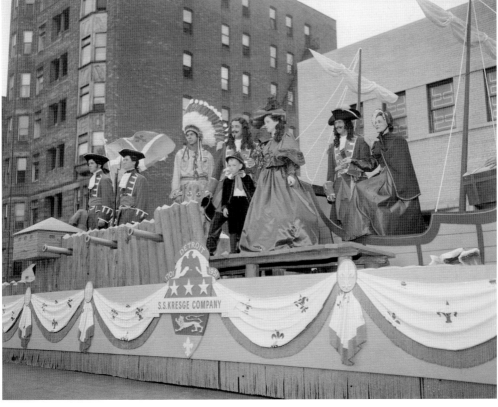

Detroit Merchant Extraordinaire
For any Detroiter born before 1970, the mention of the name J.L. Hudson brings to mind images of the Thanksgiving Parade, the annual Daisy Sale, and iconic green shopping bags. Behind the familiar store was the man, Joseph Lowthian Hudson, born in England in 1846 and raised in Hamilton, Ontario. After beginning his retail career in Detroit, he started his own men's and boys' shop in 1881. Hudson gradually expanded his business, moving from a spot in the Detroit Opera House to a location two blocks up Woodward, where it grew into a retail behemoth. He died in his native England in 1912 while traveling on business. (Courtesy of Target Corporation archives.)

A Tireless Civic Booster
Mike Illich believed in downtown Detroit before it was cool. In 1987, Illich, already the owner of the Detroit Red Wings and Little Caesar's Pizza, made the gutsy decision to buy and restore the tarnished but formerly elegant Fox Theatre. It was derided as a crazy move, but the rejuvenated venue emerged as an astonishing success, presenting concerts and musicals featuring famous names to packed houses. In 1992, Illich purchased the Detroit Tigers and built Comerica Park, the team's much-needed new home. Today, Illich continues his efforts to revive the city and provide first-class entertainment to the hockey, baseball, and theater fans of southeast Michigan. (Right, courtesy of the Walter Reuther Library; below, courtesy of the author.)

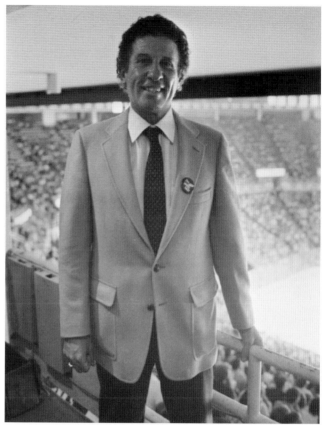

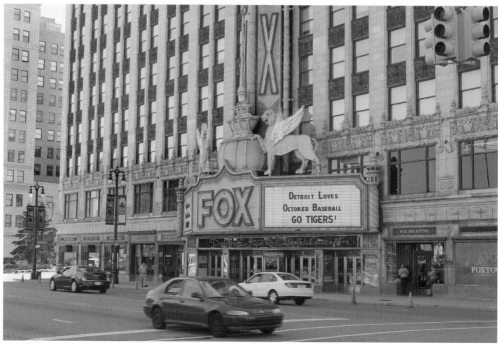

CHAPTER FOUR

Words and Music

The media is often spoken of derisively, with claims and counterclaims of bias—or the lack thereof—in news coverage projecting a negative light on the entire world of mass communication, from television, radio, and the Internet to more traditional forms like books, newspapers, and magazines. Throughout Detroit's history, however, this City of the Straits has capitalized on mass communication as a means to tell its story to the nation and to the world. Iconic radio stations, such as WJR, WWJ, WKNR, and CKLW (actually located in Windsor, but a Detroit institution nonetheless) broadcast the latest news; insightful commentary; and all genres of music, including jazz, rock, Motown, and others (many of which were historically rooted in southeast Michigan).

Detroit has also had a significant impact on the literary world. Works by Jeffrey Eugenides, Elmore Leonard, Joyce Carol Oates, and Harold Robbins have told stories—both fictional and true—of crime, politics and sex. Other Detroiters, such as George C. Scott, have represented the city on the silver screen.

Over the years, the *Detroit News*, the *Detroit Free Press* and, at one time, the *Detroit Times* have provided generations of locals with news and features of the highest quality, including the photography of Tony Spina, the advice of Nancy Brown, and the poetry of Edger Guest. The *Free Press*'s coverage of the 1967 insurrection won the paper a Pulitzer Prize, an achievement that would be repeated four decades later when the paper broke the story of the mayoral text-message scandal, which led to the downfall of Kwame Kilpatrick's administration.

Today, Detroit's media continue to document the stories of the city and the nation to the delight of an eager public.

Broadcaster Extraordinaire

The mere mention of Bill Bonds evokes a wide variety of emotions in the minds of Detroiters. A native of the city, Bonds began his career at WXYZ (Channel 7) in 1963 doing announcing work, but it was his reporting of the 1967 insurrection that brought significant notice to his talent. Recognized for his gutsy, hard-edged style of reporting, Bonds was hired by KABC in Los Angeles, where he remained for three years before returning to Detroit. Over the next three decades, his talent and his celebrity status made Channel 7 the undisputed leader in local television news, with year after year of stellar ratings. From time to time, Bonds also hosted interview shows, most notably his *Bonds On* series, in which he would question a prominent politician or corporate titan. Yet, the King of Detroit news was not without his detractors. While Bonds's brash, pugnacious manner earned him the admiration of many, other viewers came to see him as arrogant. In a live 1991 interview via satellite with Utah senator Orrin Hatch, for instance, Bonds grilled his subject, insisting that a recently leaked FBI document was nothing unusual. Hatch took exception, and the interview escalated into a shouting match, with the senator eventually walking away from the camera. Locally, Bonds frequently locked horns with politicians, business people, and sports figures. After a public exchange of insults with Detroit mayor Coleman Young, Bonds suggested an unusual way to settle the score: a public boxing match between the two men. As his tenure wore on, Bonds was frequently absent from the air for weeks at a time, often with little or no explanation from station management. In 1995, it was disclosed that Bonds suffered from alcoholism and other addictions. These problems led to his dismissal from WXYZ that same year. In the time since, Bonds has delivered occasional guest editorials on various Detroit stations, done voice-over work, and made appearances in television commercials. Today, he is recognized as the most influential broadcaster in the history of Detroit television, despite (or perhaps, because of) his enduring tough-guy image.

The "Sonny" Side of the Weather

It may sound like an overly sweeping statement, but no other television or radio station anywhere has ever had a personality like the wacky, fascinating, and energetic Sonny Eliot. Born Marvin Schlossberg in Detroit in 1920, Sonny attended Wayne University and enlisted in the Army Air Corps the day after the Pearl Harbor attack. Taken prisoner in Germany after being shot down, Sonny entertained his fellow POWs with skits and shows. After the war, Sonny began his 60-year career in the Detroit broadcast media, starring in radio show such as *The Green Hornet* and *The Lone Ranger*, as well as television programs like *At The Zoo*. His most noteworthy role, though, was as meteorologist for WWJ and WJBK, where, in addition to giving the forecast, he would delight his audiences with knee-slapping jokes and timeless anecdotes. (Courtesy of George Eichorn.)

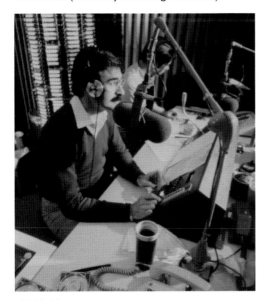

The Morning Jolt—With Extra Caffeine

While the older generation made their morning commutes with nonstop news coverage, Dick Purtan offered something different when he arrived at WKNR-AM in the mid-1960s. For the next 45 years, Purtan and his cast offered a show featuring popular music, humor, and a real sense of family to early morning listeners. Over the years, Purtan took his show across the dial (and the river, doing a stint in Windsor), broadcasting from WXYZ (1968–1978), CKLW (1978–1983), WCZY (1983–1996), and WOMC (1996–2010). Over the years, "Purtan's People" never lost their edge, keeping their audience up to date on the exploits of Mr. Michigan, Wendell Ledbetter, and "Bill" from Sterling Heights, a few of his iconic characters.

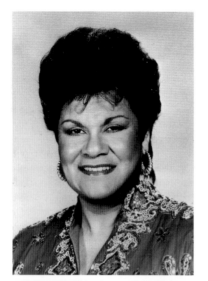

A Trailblazer on the Airwaves
Martha Jean "the Queen" Steinberg never tired of making history. After beginning a radio career in her native Memphis, Tennessee, Steinberg migrated north to Detroit in 1963. At a time when very few African American women worked in on-air positions, Steinberg broadcast her show of R & B music, interviews, and housekeeping tips, first on WCHB and later on WJLB. During the 1967 insurrection, Steinberg remained on the air for 48 consecutive hours, passionately pleading with citizens to refrain from violence. During the next few years, she hosted a call-in show called *Buzz the Fuzz* that allowed listeners to ask questions of police representatives. (Courtesy of the Michigan Women's Hall of Fame.)

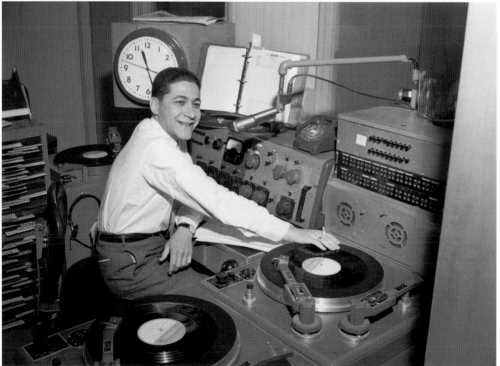

Detroit's Dick Clark
Detroit native Robin Seymour had three passions: music, broadcasting, and the younger generation. Recognizing his true calling early in life, he began his career at 19 at WKMH-AM in Dearborn, where he sensed early on the popularity the new rock-and-roll sound would have with young people. He created his hugely successful *Bobbin with the Robin* show, a daily afternoon spinning of the latest top hits. Seymour took the idea to television in 1963, starting what would eventually become *Swinging Summertime*, a show featuring teenagers dancing to live music and offering their opinions on the newest records. Very much a local institution, the show included plenty of Motown artists.

62

Mickey Shorr

Most Detroiters today will instantly recognize the name Mickey Shorr, but what first comes to mind is a chain of car-audio and electronics stores. Those born after 1970 may not know about Mickey Shorr—the person—and his colorful life. As a young man during the late 1940s and early 1950s, Shorr bounced from job to job but always ended up in radio, his true passion. By 1955, he was a fixture at WJBK-AM and was seen as Detroit's first rock-and-roll DJ. After being fired in the payola scandal of the late 1950s, Shorr tried selling used cars before beginning his first Tape Shack store in Detroit in 1967. As technology changed, the store moved away from tapes and embraced the ever-evolving world of car audio, cellular phones, and remote car starters. Shorr died in 1988, but his namesake company survives, operating in 16 locations.

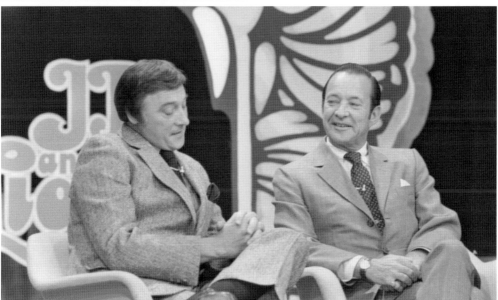

The Great Voice of WJR

Radio personality J.P. (Joseph Priestly) McCarthy (left) saw all of Detroit as his audience, and, in a very real sense, it was. A native of New York City, J.P. moved with his family to Detroit while a youngster. After learning the radio trade during a stint in the Army, he returned home and was soon hired as an announcer at WJR, the iconic station dubbed the Great Voice of the Great Lakes. After being promoted to the morning slot, he became a true community fixture. On his show *Focus*, popular music punctuated coverage of news and sports as well as talk on current local events with guest luminaries (including Detroit Lions owner William Clay Ford, right) and listener call-ins. His show enjoyed years as the top-rated Detroit morning program. Sadly, in 1995, McCarthy was diagnosed with a rare form of leukemia. He passed away in August of that year while hospitalized in New York.

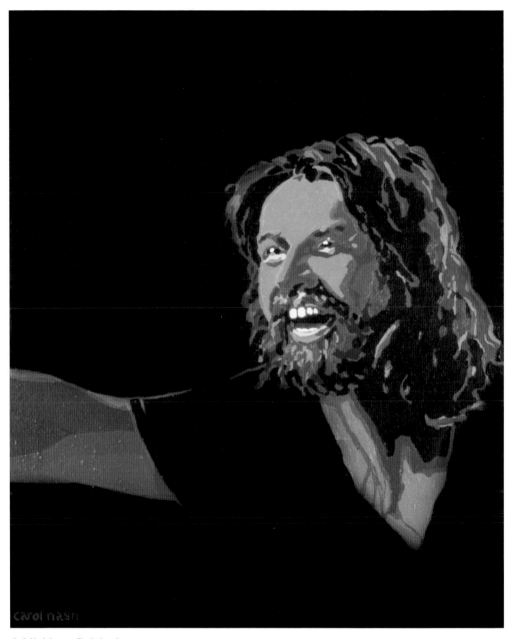

A Michigan Original

Robert Clark "Bob" Seger is undoubtedly Detroit's greatest contribution to the recording industry outside of the Motown tradition. Realizing his musical talent at a young age, Seger played with a variety of local bands while still in high school. He graduated from Ann Arbor High School in 1963 and continued his career when his band, the Bob Seger System, signed with Capitol Records in 1968. The band scored two major hits, "2+2=?" and "Ramblin' Gamblin' Man," with its debut album. After forming the Silver Bullet Band in the mid-1970s, Seger enjoyed his greatest success with songs like "Nutbush City Limits" and "Beautiful Loser." Live versions of these hits are included on his album *Live Bullet*, recorded during a live performance at Cobo Arena in Detroit in September 1975.

A Motown Ace

William "Smokey" Robinson's handprints are etched in the Motown tradition almost as deeply as Berry Gordy's. Showing musical interest at an early age, Robinson formed his first R & B group in 1955, first known as the Matadors and later as the Miracles. In 1957, the group approached Berry Gordy, who was impressed with their singing abilities and Robinson's masterful songwriting. As Gordy launched Motown in 1960, the Miracles became one of its cornerstone acts. Writing and recording smash hits such as "Shop Around," "Mickey's Monkey" and "I Second That Emotion," Robinson also penned songs for other Motown artists, including Mary Wells, the Temptations, and the Marvellettes. His early embrace of music proved infectious—for a time, his next-door neighbor was a young Diana Ross.

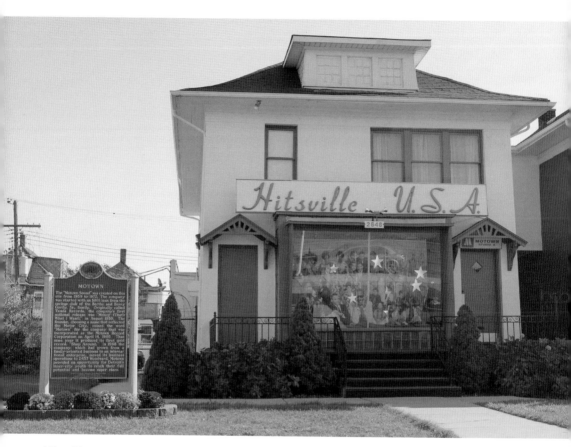

Hitsville—Detroit

Detroit's greatest contribution to music is unquestionably the Motown sound, a unique style that grew from the legacy of R & B. But it might not have happened if not for Berry Gordy (opposite). Born in Detroit in 1929, Gordy was the second youngest of eight children. He dropped out of high school, but his plans to become a professional boxer were interrupted by the Korean War. After his discharge from the military, Gordy met the owner of a downtown show bar and told him of his interest in songwriting. After penning the modestly successful "Reet Petite" for singer Jackie Wilson in 1957, Gordy went on to write several mores songs, including the hit "Lonely Teardrops." Turning to producing, Gordy incorporated Motown Records in 1960 and signed a succession of local talent, including Smokey Robinson, Mary Wells, the Supremes, the Temptations, and numerous others, carving out a unique musical niche that defined 1960s Detroit. (Above, courtesy of the author; opposite, courtesy of the Walter Reuther Library)

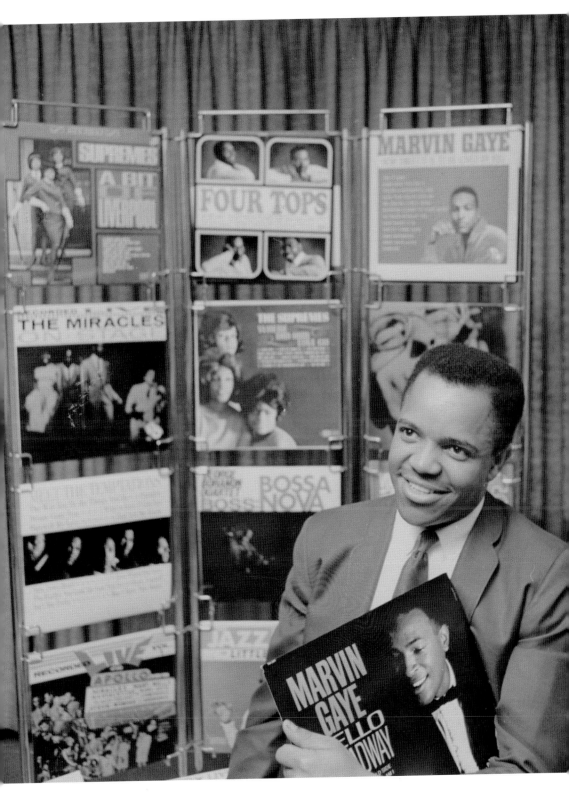

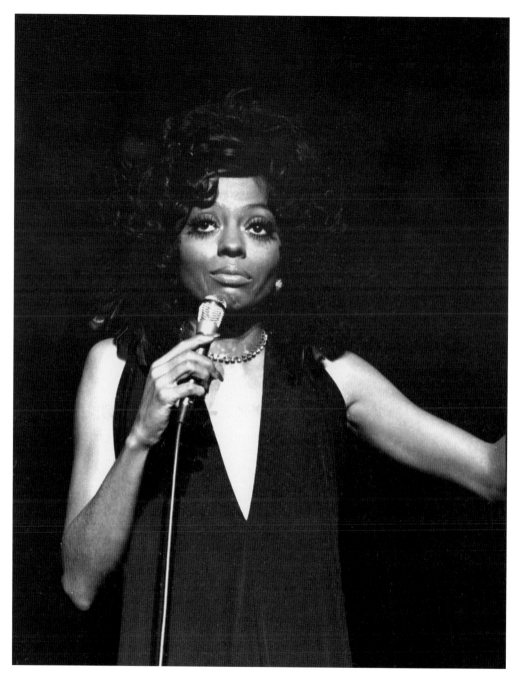

Diana Ross
One of Motown's earliest artists, Ross was a part of a quartet of female singers known as the Primettes when they first formed in 1960. A year later, while still in high school, Berry Gordy signed them with the stipulation that they change their name. Rebranded as the Supremes, the group contracted to just three members: Ross, Mary Wilson, and Florence Ballard. During the mid-1960s, Ross emerged as the lead singer of the group, which saw great success with hits like "Where Did Our Love Go?" and "Mr. Postman." Leaving the group in 1970, Ross went on to a lengthy solo career.

Detroit's Poet Laureate

Dudley Randall was born in 1914 in Washington, DC, and moved to Detroit with his family at the age of six. While still young, he discovered his literary talents, particularly a love for poetry. Making his living as a reference librarian, Randall used his craft to reflect on some of the most tragic events of the 20th century. In the *Ballad of Birmingham*, Randall offers his thoughts on the 1963 church bombing in Birmingham, Alabama, which killed four young girls. In 1965, Randall established the Broadside Press, a small Detroit-based publisher dedicated to promoting the work of African American poets. Projects included his book *Cities Burning*, a collection of poems on the 1967 insurrection, and *Poem Counter Poem*, a book he coauthored with Margaret Danner. In 1981, Randall was named Poet Laureate of the city of Detroit by Mayor Coleman Young. (Courtesy of Dr. Melba Boyd, Wayne State University.)

The People's Poet

Highly prolific writer Edgar Guest (left) distinguished himself by creating a unique brand of warm, empathetic poetry. Hired in 1895 at the *Detroit Free Press*, the native of Birmingham, England, distinguished himself over a 60-year career, sharing with readers his thoughts on the themes on everyday living, human potential, and spirituality. His daily column, "The Breakfast Table Chat," emerged as one of the paper's most popular features. By the end of his career, Guest had written more than 11,000 poems, which were syndicated in some 300 newspapers. His published collections of poetry included *A Heap O' Livin'* and *Harbor Lights of Home*.

Detroit Reflected in Literature

Prolific, insightful, timeless—these three adjectives merely begin to describe celebrated author Joyce Carol Oates. A native of Lockport, New York, Oates came to Detroit in 1962 to take a teaching position at the University of Detroit. While there, she produced the most memorable works of her career, including *With Shuddering Fall*, *A Garden of Earthly Delights*, and *them*, which won a National Book Award. Many of her works explore the tensions of the working class and the suffocating effects of poverty and crime. Influenced by the city's 1967 insurrection, *them* proved impactful on the author herself, later prompting her to write, "Detroit, my 'great' subject made me the person I am, consequently the writer I am—for better or worse."

A Streetwise Scribe

Elmore Leonard has never lost his fascination with the criminal mind, tirelessly exploring its many corners and crevices. His literary talent, which he discovered at an early age, and his childhood experiences of the Depression, Prohibition, and organized crime, provided the foundation for his success. While working as an advertising copywriter during the 1950s, Leonard wrote Western novels and short stories in his spare time. One of his early works, *3:10 to Yuma*, was adapted as a motion picture. After turning to writing full time, Leonard switched to the genre of crime novels, many of which are set in Detroit. Drug lords, street gangs, and pimps frequently dominate his works, which include *Rum Punch, Get Shorty*, and *Up in Honey's Room*. To date, he has written 45 novels, over a dozen of which have been taken to the screen.

George C. Scott

Although not originally from Detroit, Scott was raised in the Motor City and attended Redford High School. While there, he worked diligently to pursue his first dream: writing. While studying journalism at the University of Missouri, Scott turned to acting and pursued it as his vocation. His early career was on stage, with a 1959 Broadway debut in *The Andersonville Trials*. Scott later took on dramatic parts in both movies and television, including *Dr. Strangelove* and *Patton*. For the latter, Scott won (and famously turned down) the Academy Award for Best Actor.

A Pie in the Face

The Detroit comedy scene took a turn in the slapstick direction in 1953 when Milton Supman, better known as "Soupy Sales," began doing his hilarious *Lunch With Soupy* show on WXYZ-TV (Channel 7). The program, aimed at children, was a laugh a minute, offering all sorts of jokes and skits climaxing with Soupy getting a pie thrown in his face. Helping Soupy out were his partners in crime, the puppets White Fang and Black Tooth. Other cast members included Soupy's girlfriend, Peaches (actually Soupy in drag). After 1960, Sales's show moved to Los Angeles, and later, to New York, but he maintained a fondness for Detroit, often returning to film guest appearances and commercial spots. (Courtesy of the Burton Historical Collection, Detroit Public Library.)

A Friend who Made Us Laugh

Detroit native Gilda Radner spent her too-short life doing what came naturally to her: entertaining people through comedy. After attending the University of Michigan, she moved to Toronto in 1972 and became part of the Second City comedy troupe. In 1975, she was a charter cast member of NBC's long-running hit, *Saturday Night Live* (*SNL*). Allowed to display the depth of her talent, she delighted audiences with characters like Baba Wawa and Roseanna Roseannadanna. Her *SNL* success led to bigger projects, including the films *The Woman in Red* (1984) and *Haunted Honeymoon* (1986), in which she costarred opposite her husband, Gene Wilder. Sadly, she passed away from ovarian cancer in 1989. Soon after her death, a nationwide network of support communities for cancer patients was established. Known as Gilda's Club, a Detroit-area location serves patients in Royal Oak. (Left, courtesy of the Michigan Women's Hall of Fame; above, courtesy of the author.)

Through the Lens of an Artist
A good photograph can communicate thoughts and feelings unlike any other medium. Few people have mastered this craft more expertly than Tony Spina (shown here at the Vatican with Cardinal John Dearden), who worked as a photographer at the *Detroit Free Press* from 1946 until his retirement in 1995. Learning the trade as a photographer's mate in the US Navy during World War II, Spina excelled at both the technical and creative aspects of photojournalism, making his mark with some of the most memorable images of the 20th century. Among his subjects were US presidents from Eisenhower through Reagan, popes from John XXIII to John Paul II, and a wide array of historic places and events, including the Western Wall in Jerusalem, the Second Vatican Council, the 1968 World Series, and the 1967 Detroit insurrection.

CHAPTER FIVE

Artists and Artisans

While mass industrialization remains the dominant image of modern-day Detroit, a peek just below the surface will reveal an abundance of artistry and handicraft too often overlooked. There are noteworthy buildings like the Detroit Institute of Arts and the David Whitney mansion, as well as works of public sculpture, architectural masterpieces, and the occasional offbeat display of public creativity.

In many instances, native or longtime Detroiters are responsible for these aesthetic additions to the city, which beautify and enrich the entire community. Fortunately, they do not go unnoticed by out-of-town visitors. In his impressive book *American City: Detroit Architecture, 1845–2005*, Chicago author Robert Sharoff discusses his unexpected amazement when he and photographer William Zbaren surveyed downtown's streetscape for the first time:

> And yet, everywhere we looked, there was a marvel of some kind: a flawless Beaux-Arts bank tucked away in the old financial district, half a dozen glittering Art Deco skyscrapers, a dramatic stainless steel fountain on the river front.

Sharoff and Zbaren were especially struck with how underappreciated these architectural treasures are by locals.

It may be surprising to many Detroiters how well represented the city is in the pantheon of architecture and public art. For example, the majestic (yet still abandoned) Michigan Central train station was designed by Warren & Wetmore, the famous New York firm that also produced Grand Central Terminal. Finnish architect Eliel Saarinen was persuaded by publisher George Gough Booth to come to Michigan to design his Cranbrook campus, and renowned French sculptor Auguste Rodin's signature adorns the bronze cast of his work *The Thinker* (one of less than 30 such casts worldwide) in front of the Detroit Institute of Arts.

The Sculptor of Detroit

Marshall Fredericks is clearly the name most often connected with sculpture in Detroit. A native of Rock Island, Illinois, Fredericks graduated from the Cleveland School of Art in 1930 and spent the next two years studying in Europe, including a fellowship with Swedish artist Carl Milles. After accepting a teaching position at Cranbrook Academy of Art in 1932, Fredericks demonstrated his affection for public pieces of sculpture that all people could enjoy. Throughout his prolific career, he created noteworthy works worldwide, with the *Spirit of Detroit* becoming his most popular locally. Another, *Harlequins, Ballerina and Orchestral Parade*, which once resided in the lobby of Ford Auditorium, has been moved to the Marshall Fredericks Sculpture Museum at Saginaw Valley State University. *Friends, Big and Small* beautifies Quarton School in Birmingham. (Above, courtesy of the Walter Reuther Library; left, courtesy of the author.)

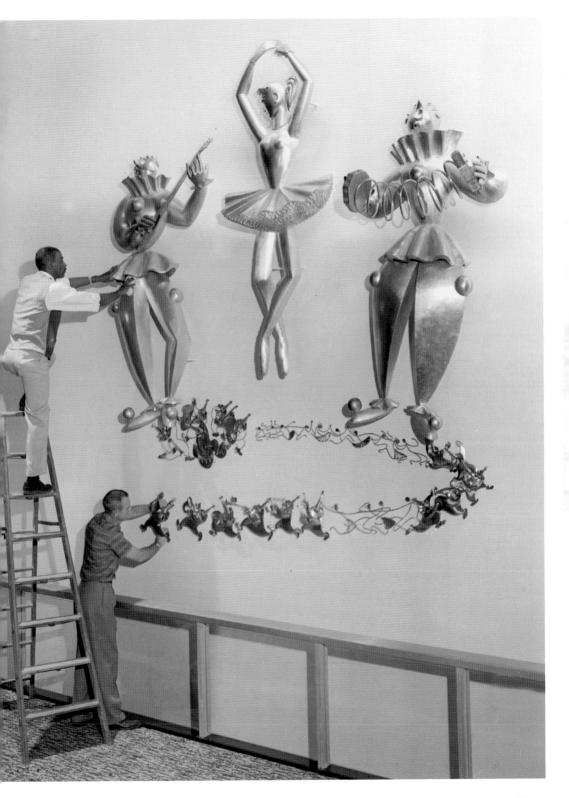

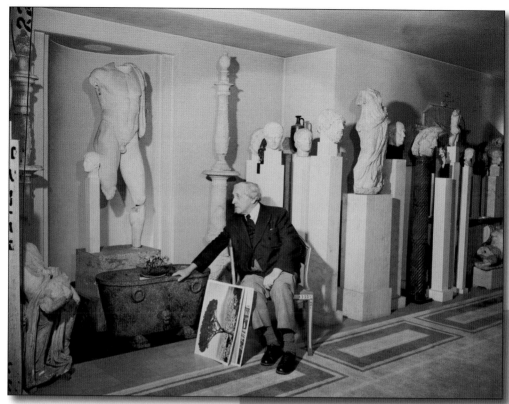

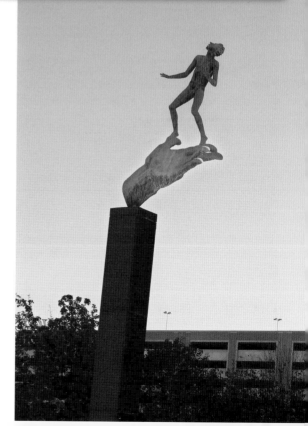

Elegant Fountains for America
In 1932, publisher George Gough Booth recruited sculptor Carl Milles from Sweden to become part of his developing Cranbrook Art Academy in Bloomfield Hills. After arriving, Milles fulfilled another of Booth's requirements: accepting commissions outside of academia. Milles went on to design elaborate public fountains for St. Louis, Missouri; Dallas, Texas; and Rochester, Minnesota, in addition to his much-loved fountains on the Cranbrook Campus—*Orpheus*, *Triton*, and *Jonah and the Whale*. *The Hand of God*, outside the Frank Murphy Hall of Justice (right) is another of his creations. After his 20-year career in America, Milles returned to Sweden in 1952. He died in 1955. (Above, courtesy of the Walter Reuther Library; right, courtesy of the author.)

Detroit's Exponent of Arts and Crafts

Mary Chase Stratton's lifelong love of sculpture led to her creation of Pewabic tile and pottery, a genre of simple clay creations adorned with an iridescent glaze (the formula for which she kept secret). After realizing the widespread appeal of her work, she opened her factory, Pewabic Pottery, in 1903. In 1907, success prompted her to move into new quarters at 10125 Jefferson Avenue in an Arts and Crafts–style building designed by her husband, William Stratton. The immense popularity of her tiles is strongly evident throughout Detroit and Michigan today. Countless public buildings and private homes sport her work, including the Fisher Building, the Cathedral Church of St. Paul, and Sacred Heart Seminary. After her death in 1961, the business became a nonprofit and continues to operate today. (Above, courtesy of the author; below, courtesy of the Walter Reuther Library.)

Art With a Human Face

Where most people saw a desolate neighborhood, Tyree Guyton saw possibility. After serving the US Army during the 1970s, Guyton returned to the block of Heidelberg Street where he grew up and was shocked at the decline that had occurred since the 1967 insurrection. After studying art, Guyton and his grandfather Sam Mackey conceived the idea of transforming the neighborhood itself into a work of art, one that would inspire residents and lure in the curious. As part of the Heidelberg Project, as it was dubbed, the duo adorned homes with florescent polka dots, placed brightly painted abandoned cars in vacant lots, and even decorated the pavement with vivid designs. Today, the Heidelberg Project attracts visitors from across the world. (Courtesy of the Heidelberg Project.)

Patricia Hill Burnett

A woman of true determination, Patricia Hill grew up in a single-parent home in Toledo, Ohio, and discovered her artistic talent at a young age. After studying art at Goucher College in Baltimore, she moved to Detroit with her family and began a very successful portrait-painting career, counting among her clients Corazon Aquino, Margaret Thatcher, and Marlo Thomas. Realizing, however, that women in the mid-20th century were still faced with numerous inequities, Burnett later turned her energy to the feminist cause, serving on numerous commissions to promote the role of women. In 1974, she was named Feminist of the Year by the National Organization for Women. (Courtesy of the Michigan Women's Hall of Fame.)

A Master Craftsman
A native of Finland, Eliel Saarinen brought to America a well-defined style plus a willingness to continually update his philosophy of design. After a successful career in Europe, Saarinen immigrated to the Midwest in 1923, settling in the Chicago area. His entry in the Tribune Tower competition, despite finishing second, proved highly influential. His designs respected traditions of the past, but rather than copy them, Saarinen sought to creatively integrate the emerging Arts and Crafts style with English Gothic. Recruited by George Booth to design his Cranbrook campus in 1925, Saarinen produced brilliant designs evocative of the best of European and American architecture, including Cranbrook and Kingswood Schools, the Cranbrook Academy of Art and Museum of Art, and the Institute of Science.

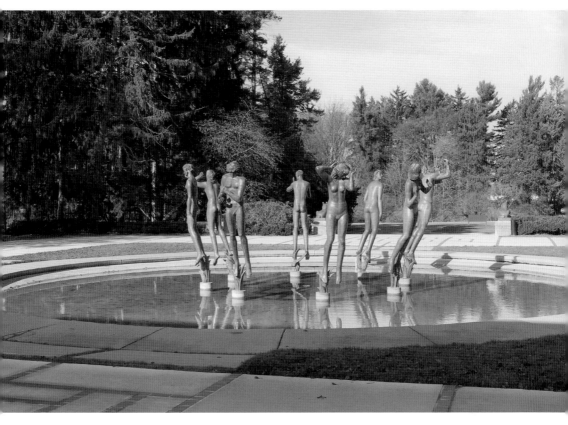

A Benefactor of the Arts

George Gough Booth, son-in-law to *Detroit News* founder James Scripps, was neither an artist, architect, or educator. However, holding each of these professions in the highest esteem he used his wealth and influence to leave a legacy of culture from which Detroiters continue to benefit today. While on a country picnic in the then-distant countryside of Bloomfield Hills in 1903, Booth became awestruck by the beauty of the pastoral landscape, which, with its hills and streams, reminded him of the Booth family's ancestral home of Cranbrook, England. That chance experience prompted him to purchase a tract of the 100-acre farm. Hiring caretakers and craftsmen to tend the crops and repair the existing buildings, Booth set about to achieve a personal dream—the creation of an educational community devoted to nurturing artistic talent. Soon after acquiring the land, Booth commissioned architect Albert Kahn to design a home for him and his wife, Ellen. The next few years saw the construction of the outdoor Greek Theatre, Christ Church Cranbrook, and the Brookside School for young children. In 1924, George and Ellen's son Henry Scripps Booth graduated from the architecture school at the University of Michigan. He introduced his parents to Eliel Saarinen, a visiting professor from Finland, whom George Booth recruited to come to Bloomfield Hills to design his planned expansion of Cranbrook. Booth and Saarinen shared an enthusiasm for the Arts and Crafts style of architecture and design, which emphasized simplicity and the use of natural materials. Saarinen made Booth's vision three dimensional, completing the Cranbrook Academy for Boys in 1930, the Kingwood School for Girls in 1931 and the Academy of Art in 1932. Booth envisioned the Cranbrook Academy of Art to resemble schools in Europe. Each student would specialize in one of 10 areas, such as painting, sculpture, ceramics, or photography. Throughout students' academic careers, an artist in residence would serve as their personal mentor, and all projects would result from their mutual interaction. Still employing this method today, Cranbrook has had national and international impact, educating such figures as Harry Bertoia, Charles Eames, Eero Saarinen, and Lorraine Wild. (Left, courtesy of the Walter Reuther Library; above, courtesy of the author.)

The Architect of Detroit

Even the most casual observer of Detroit architecture will recognize the name Albert Kahn. During his long career, Kahn put his unique signature on the city in a variety of residential, commercial, and industrial buildings that featured his eclectic mix of styles, which often drew inspiration from Renaissance Italy and ancient Greece. Kahn, a rabbi's son, was born in 1869 in Rhaunen, Westphalia, Germany. After coming to the United States at the age of 11, Kahn displayed early interests in both art and architecture. He aspired first to a career in art, but color blindness forced him to abandon this goal. In 1891, after working as an apprentice at the Detroit architectural firm of Mason & Rice, Kahn began studying in Europe. Although he was not enrolled in any formal academic program, he traveled extensively, collaborated with other architects, and drew prolifically. After returning to Detroit, he resumed his position at Mason & Rice and then worked at various other firms before beginning his own practice in 1903. Much of Kahn's early work was in industrial design. Partnering with his brother Julius, a structural engineer, he developed the idea of steel-reinforced concrete, a method that would produce much stronger buildings. The enormous Packard Assembly Plant, the Kahns' first use of this concept, would soon earn them numerous other commissions, including Henry Ford's new facility in Highland Park. Early in World War II, Ford would again hire Kahn to design a massive plant near Willow Run Airport in Ypsilanti for the production of European-bound B-24 Liberator bombers. At peak production, the mammoth plant produced planes at a rate of one per hour. During subsequent years, Kahn produced a plethora of Detroit structures, many of which define the city's character today, including the Fisher Building; the Kales Building; the Belle Isle Aquarium; the offices of the *Detroit News* and the *Detroit Free Press*; and his own personal residence on Mack Avenue (left), which is now home to the Detroit Urban League. His completion of the Detroit Athletic Club in 1915 was mired in controversy, for despite residing in a building designed by a Jewish architect, the club did not accept Jewish people for membership at the time. For this reason, Kahn declined an invitation to a formal luncheon celebrating the building's opening. (Top, courtesy of the Walter Reuther Library; bottom, courtesy of the author.)

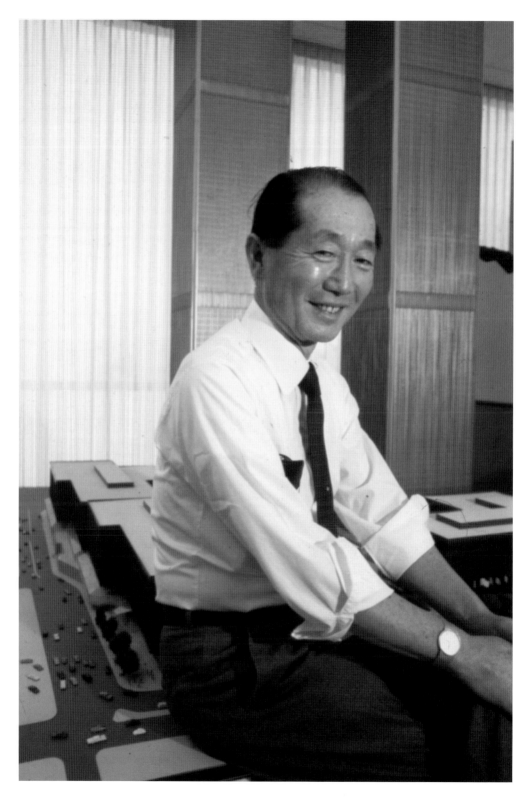

A Genteel Side to Modernism

One of Detroit's most fortuitous twists of fate was Minoru Yamasaki's decision to make the city his home. Known as a Nisei (an American child of Japanese parents), Minoru was born in 1912 in Seattle, Washington. Overcoming anti-Asian racism throughout his youth, Yamasaki (or "Yama," as he would come to be known) attended the University of Washington, obtaining a bachelor of arts degree before moving to New York to study at New York University and then work for various New York firms, including Shreve, Lamb & Harmon, designers of the Empire State Building. He was living in New York at the time of the Pearl Harbor attack and persuaded his parents to move east to avoid being sent to the Japanese internment camps on the West Coast.

Yamasaki moved to Detroit in the 1950s and went to work for Smith, Hinchman & Grylls before setting up his own firm. His early projects, including the Lambert-St. Louis International Airport and the Pruitt-Igoe housing project (both located in St. Louis, Missouri), were pure examples of mid-20th century modernism, largely in the tradition of Ludwig Mies van der Rohe. In the latter part of the decade, though, Yamasaki took an extended trip to the Far East and Europe. Admiring the various styles of the buildings he observed, he returned to the United States personally transformed. Going forward, his designs—while still classified as modern—began to take on a softer, more genteel look, often incorporating some of the elements he so admired, such as arched windows recalling Gothic cathedrals and pearl-white marble exteriors recollecting the Taj Mahal. His most significant contributions to Detroit came soon after, including the McGregor Conference Center (below) and the DeRoy Auditorium, both on the campus of Wayne State University; One Woodward Avenue; the Reynolds Aluminum building in Southfield; and Temple Beth El in Bloomfield Hills. Yamasaki's greatest work, of course, was the original towers of the World Trade Center in New York, which he envisioned as a center for cooperation between all people through commerce, the noblest of human pursuits. (Opposite, courtesy of the Walter Reuther Library; below, courtesy of the author.)

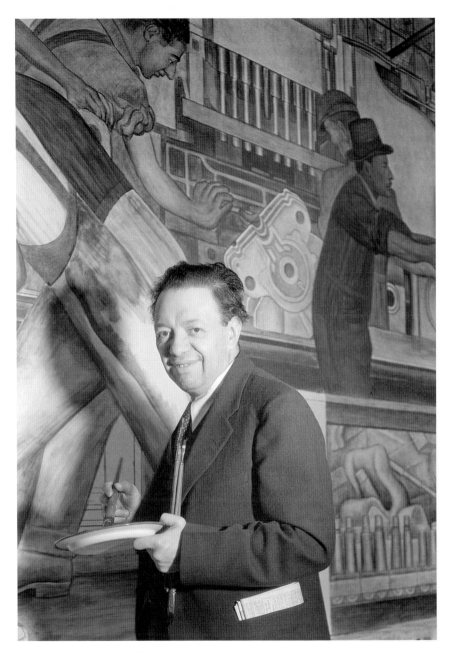

The Artist and the Industrialist

In 1931, lifelong art devotee Edsel Ford commissioned accomplished Mexican muralist (and known communist) Diego Rivera to design and produce a series of murals depicting the automotive industry in what up until then had been an exposed courtyard at the Detroit Institute of Arts. While fully aware of Rivera's political views, Ford stressed his work must not cast Ford Motor Company in an overly negative light. The work, which took the form of two major murals flanking each other and several smaller images, depicted production of engines and automobiles at the Ford Rouge plant and covered themes of 20th-century technological progress. The work proved popular but highly controversial, with Edsel Ford himself interceding to thwart calls for the murals' destruction. (Courtesy of the Detroit Institute of Arts.)

CHAPTER SIX

All Things Spiritual

Like virtually every American city, Detroit can claim a highly diverse mosaic of religious institutions, representing virtually every theological tradition. While Christianity—including the largest denominations (Baptist, Catholic, Lutheran, and Methodist) as well as smaller groups (Christian Science, Mormon, and Unitarian-Universalist bodies)—accounts for some 90 percent of metropolitan Detroit's population, Judaism, Islam, and Buddhism are also well represented.

And, as in most other large cities, a deep, almost inextricable link is shared between the greater Detroit community and its religious institutions. While this connection generally yields positive benefits, such as increased tolerance and understanding, there have been noteworthy exceptions.

In 1836, after being refused membership in Detroit's all-white First Baptist Church, 13 freedmen from the South were motivated to begin their own congregation. Second Baptist soon became a final link along the Underground Railroad, helping escaped slaves cross the Detroit River to freedom in Canada.

In the early 1930s, Rev. Charles Coughlin, pastor of Shrine of the Little Flower in Royal Oak, ended his support for Pres. Franklin Roosevelt and the New Deal and established the National Union for Social Justice, an affiliate of the Union Party. The latter was a third political party that, among other things, advocated radical monetary reforms and fostered a deep distrust of banks. Coughlin used his weekly national radio program to promote these fears, often in a decidedly anti-Semitic tone.

Despite these shortcomings, the city's faith community has for decades helped meet both the spiritual and material needs of Detroiters. The charitable works of Revs. Solanus Casey and Clement Kern, the enlightened theological leadership of Rev. Reinhold Niebuhr, and the interfaith work done by Rabbi Leo Franklin have all done immeasurable good—providing ongoing blessings to an ever-grateful city.

Rabbi Leo Franklin

An unabashed religious progressive, Rabbi Leo Franklin served as spiritual leader of Temple Beth El from 1899 until his death in 1948. After serving at another Reform congregation in Omaha, Nebraska, for several years, Franklin delivered a guest sermon in Detroit in 1899. His presentation made such a favorable impression that he was offered the pulpit. Franklin assumed his new role with the same style of ministry he had cultivated throughout his early career—a thoughtful, measured, yet steady updating of Jewish religious practices. Developments included the promotion of new charitable causes, modifications to the liturgy (including an end to assigned seating and recognition of the equality of women), the construction of a new temple in 1902 in an area near several Christian churches, and greater interaction with the non-Jewish community. These efforts proved immensely popular and established Temple Beth El as one of the most prominent Reform Jewish congregations in the nation. By 1920, as many members moved further uptown, Franklin was instrumental in the building of a new facility three miles away at Woodward Avenue and Gladstone Street (shown). One of the greatest challenges of his career, however, came not from within his congregation but from a neighbor with whom he shared the same block of Edison Street: a man named Henry Ford. Beginning around 1910, Franklin and Ford met and became friends. Soon after, Ford offered Franklin a new Model T each year to aid in his pastoral work. In 1920, however, Ford purchased a small newspaper, the *Dearborn Independent*, which soon published *The International Jew: The World's Problem*, a series of intensely anti-Semitic pamphlets reviving many long-discredited myths concerning rumored Jewish domination of the media, banking, and international politics. The explosive nature of the text proved traumatic to Franklin given the personal relationship he shared with Ford. After the articles continued to appear, Franklin returned his car in protest. Ford issued a retraction and apology in 1927 in response to a libel suit, but while their relationship improved slightly, it never fully recovered. (Above, courtesy of the Rabbi Leo M. Franklin archives at Temple Beth El; opposite, courtesy of the Walter Renther Library.)

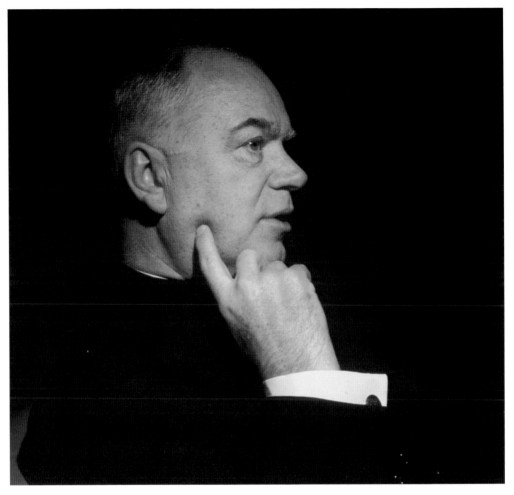

The Unobtrusive Liberal

Arriving in 1958 to serve as the new Roman Catholic archbishop of Detroit, John Dearden was a man with a reputation for being rigid and authoritarian. After nearly a decade as bishop of Pittsburgh, Pennsylvania, he had earned the nickname "Iron John" with his stern and unbending style of administration. Initially, he continued this pattern in Detroit. Shortly after taking office, for instance, he issued a curfew for all nuns in the diocese, mandating that they be off the street by 8:00 p.m. each evening. In 1962, Dearden attended the Second Vatican Council in Rome. The convocation of the world's bishops was called by Pope John XXIII with the intention of bringing the Catholic Church into the modern era. Dearden's views were transformed as he listened to and participated in the deliberations with his ecclesial colleagues. A new, progressive mood took hold of the council; this in turn prompted it to issue new norms regarding the nature of the Church, its role in society and the liturgy. Dearden participated in each session from October 1962 until the council's conclusion in December 1965. Upon returning to Detroit, he moved swiftly to implement the resulting changes far more quickly than did other US bishops. Conservative forces in the Church exerted considerable pushback, tagging Archbishop Dearden with a new nickname, "the unobtrusive liberal." Under Dearden's leadership, the remainder of the 1960s and the 1970s proved to be a dynamic period for the Archdiocese of Detroit. He led with vision and grace, and his accomplishments included overseeing the restoration of the permanent diaconate (an office discarded by the Church for over 1,000 years), adopting a more aggressive stance toward achieving social justice and ushering in a new level of transparency with respect to the diocese's finances.

A Proud Man— A Strong School

Native Detroiter Rev. Malcolm Carron (left) never lost confidence in his university or in his hometown. After graduating from the University of Detroit in 1939, he entered the Society of Jesus and spent the next several years in formation and further education. He returned to Detroit for a career in administration, and his tenure included 13 years as university president. He believed passionately in service to the greater community, and his outside work led to involvement with Boys Hope of Detroit, the Detroit Economic Club, and the United Way of Southeast Michigan. He was also a founding member of New Detroit, the urban coalition formed in the wake of the 1967 insurrection.

A Tragedy in Southfield

Rabbi Morris Adler (left, at left; far right, below) believed strongly in education, a belief underscored by the fact that the word *rabbi* comes from the Hebrew for "teacher." After assuming the pulpit at Congregation Shaarey Zedek in 1938, Adler worked tirelessly to promote adult Jewish education and offered rich, detailed sermons chronicling the history of the Jewish people and their relationship to all of humanity. His work was interrupted for a time during World War II when he served as an Army chaplain. In the early 1960s, he facilitated the congregation's move from its longtime home on Chicago Boulevard to suburban Southfield. Sadly, on February 12, 1966, calamity struck during the weekly Shabbat service. After delivering a sermon on the life of Abraham Lincoln, Richard Wishnetsky, a mentally disturbed 23-year-old member of the synagogue, came forward and shot Rabbi Adler before turning the gun on himself. Adler died one month later. (Courtesy of Congregation Shaarey Zedek archives.)

The Conscience of Detroit

During his long pastorate at Most Holy Trinity Catholic Church (1948–1977), Rev. Clement Kern studiously observed the changes happening in Corktown, the neighborhood surrounding his parish. Originally an Irish enclave with roots going back to the 19th century, the decades following World War II saw a gradual transition in the area. Most of the Irish families had grown more affluent and began moving to the suburbs, while Mexican and Maltese immigrants were arriving. Many of these newcomers were poor, and the growing phenomenon of urban deindustrialization contributed to growing unemployment and increasing levels of poverty. Reverend Kern used innovative methods to address these problems. Partnering with a group of spirited volunteers, he established free legal and medical clinics to help the indigent, as well as an emergency open-door office, which distributed essentials such as small amounts of cash or food. But Kern's efforts did not stop there. Working to address the causes of poverty, he developed long-standing relationships with corporate leaders, local judges and politicians, and labor unions to foster community investment and adult literacy. One particularly creative method to promote his goals was the annual Sharing of the Green celebration. Each St. Patrick's Day, Reverend Kern would celebrate a noon mass that would be attended by an overflowing crowd of local dignitaries and other supporters who would contribute large sums to his ongoing charitable efforts. This event, which has been continued by his successors, remains a red-letter day for Detroit's movers and shakers. Following his 1977 retirement, Reverend Kern became pastor in residence at St. John's Provincial Seminary in suburban Plymouth, where he taught courses on urban ministry and became a source of inspiration to the seminary community. He died in 1983 of injuries sustained in a traffic accident, but his legacy of concern and compassion continues to live in the hearts of Detroiters today.

Miracles on Mount Elliot Street

A simple man who led a deliberately simple life, Bernard Francis Casey (center) was born on a farm in Oak Grove, Wisconsin, in 1870. After reaching adulthood, he worked a series of odd jobs before deciding to enter Catholic religious life. Eventually, he became part of the Order of Friars Minor, or Capuchins, a community of religious men dedicated to helping the destitute and homeless. He took the name Solanus in honor of a 17th-century Spanish saint and labored in monasteries in the New York area before being sent to Detroit in 1924. There, he resided at the St. Bonaventure Monastery on Mount Elliot Street. Throughout both his manual and ministerial work, he brought peace and hope to thousands, many of whom attested to his healing powers. Today, he is being considered for Catholic sainthood. (Courtesy of St. Bonaventure Monastery.)

Mother Charleszetta Waddles

Charleszetta Waddles loved to read the Bible. To her, the passages that emphasized the necessity of doing good for others were far more relevant than obscure theological dogmas. Waddles moved to Detroit from St. Louis, Missouri, in 1933, and, finding herself in need, she supplemented what she received from public assistance by selling barbecued food to passersby outside her home. Despite being poor herself, she soon launched a "one woman war on poverty," collecting donations of food and clothing to give to those in the greatest need. Soon, she opened the Mother Waddles Perpetual Mission, which served hot meals, offered classes in basic vocational skills, and ran a program accepting donations of used cars (the proceeds from which would further fund her mission). (Courtesy of the Michigan Women's Hall of Fame.)

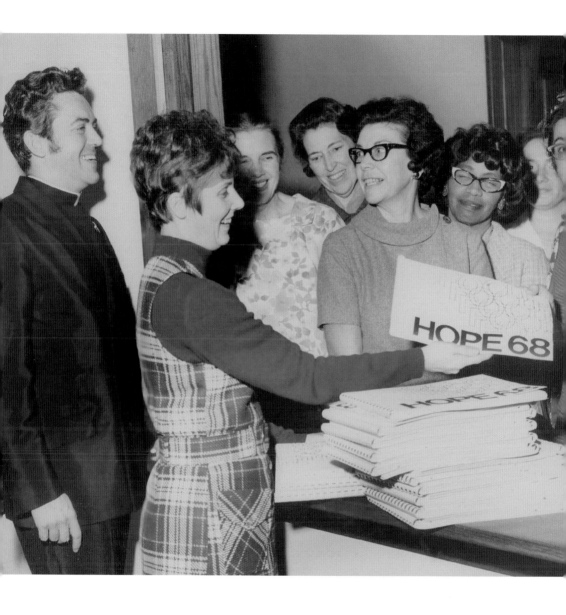

A Leader and a Visionary

During the 1960s, Rev. William Cunningham (left), an English professor at Sacred Heart Seminary, saw the effects of what he called "the malignancy of racism." Discrimination and urban disinvestment led to ever-accelerating blight, declining schools, and growing hopelessness. Seeing this trend explode after the 1967 insurrection, Cunningham took action. He partnered with community leader Eleanor Josaitis (center) to form Focus: Summer Hope, a project planned for the summer of 1968 to bring the greater community together to prevent a repeat of the previous year's troubles. The following March, shortly after the group formulated its mission statement, the need for action was underscored by the murder of Rev. Martin Luther King. Cunningham realized that before the issue of poverty could effectively be addressed, the root causes would first need to be identified. In 1968, he and Josaitis recruited a team of volunteers to examine how core city businesses treat their customers compared to their suburban counterparts. They found higher prices and poorer service at the urban retailers that sold basic necessities. In response, the organization evolved into Focus: HOPE and began a food bank for the needy, taking advantage of federal programs offering surplus food, which would otherwise spoil in government warehouses. To combat high unemployment, Focus: HOPE began the Machinist Training Institute, recruiting retired machinists and toolmakers to teach industrial skills. In later years, programs in advanced manufacturing, high school completion, resume writing, and job interview skills would be offered. In recognition of the fact that single parents would be among those most in need of these programs, the Focus: HOPE Center for Children was established, offering an array of child care and educational options for youngsters. Most of these programs are housed on Detroit's west side in a row of previously abandoned industrial buildings along Oakman Avenue, all of which have been thoroughly renovated. Collectively, thousands of Detroit residents have been helped by one or more of these programs over the years. Cunningham and Josaitis's heroic and massive efforts to transform the city and eradicate poverty, racism, and injustice continue today, a source of pride for all Detroiters. (Courtesy of Focus: HOPE.)

In the Tradition of Dorothy Day
During the 1960s, while studying theology in Europe, Tom Lumpkin had the opportunity to travel throughout the continent. He took note of the severe poverty and hunger in France, Italy, Germany, and other countries, a reality that usually went unseen by tourists. After returning to Detroit and being ordained a Catholic priest, he was unable to purge those images from his mind. In 1971, he left ordinary parish work and founded Day House Detroit, a residence of like-minded people who serve the urban poor in the tradition of the Catholic Worker movement established by Dorothy Day in New York during the 1930s. Reverend Lumpkin's principle work is the operation of the Manna Soup Kitchen at St. Peter's Episcopal Church. (Courtesy of Rev. Tom Lumpkin.)

CHAPTER SEVEN

Teams of the "D"

While citizens of every US city will claim their teams are the best, their fans the most enthusiastic, and their community's sports history the richest, there is something in the DNA of Detroit that truly does make the Motor City an athletic standout. Decades of loyalty to—and frustration with—the local professional teams of the four major sports have provided a cohesive element to the city, uniting Detroiters of different races, classes, and social backgrounds. The Tigers' World Series victory in 1935 lifted the city's spirits, which had been brought low by the weight of the Great Depression. That same year, Detroit earned the title "City of Champions" when the Red Wings captured the Stanley Cup and the Lions claimed the NFL crown in an era prior to the Super Bowl.

The Tigers' World Series victory in 1968 was widely credited with preventing a repeat of the urban insurrection that had shaken the city one year earlier, and many will remember the pride felt throughout southeast Michigan in 1997 when the Red Wings won the Stanley Cup for the eighth time in team history but for the first time since 1955. The sports legends produced during the 20th and 21st centuries in Detroit compose a veritable who's who to rival any city, among them Ty Cobb, Gordie Howe, Hank Greenberg, Barry Sanders, Steve Yzerman, Al Kaline, and Dave Bing (the city's current mayor).

Mr. Hockey

A native of Saskatoon, Saskatchewan, Gordie Howe took up Canada's national sport at a young age, eventually signing with the Detroit Red Wings in 1946 at the age of 18. Taking up the position of right guard, Howe proved valuable by utilizing his ability to shoot either right or left handed (a possibility in the era before curved sticks). Soon, Howe became part of the "production line" trio with teammates Sid Abel and Ted Lindsey, and their combined efforts earned them the first-, second-, and third-place spots respectively in the league for scoring for the 1949–1950 season. A little-known fact about Howe is that, during the off seasons of the early 1950s, he played baseball as a member of the Saskatoon 55s in the Northern Saskatchewan League. (Courtesy of George Eichorn.)

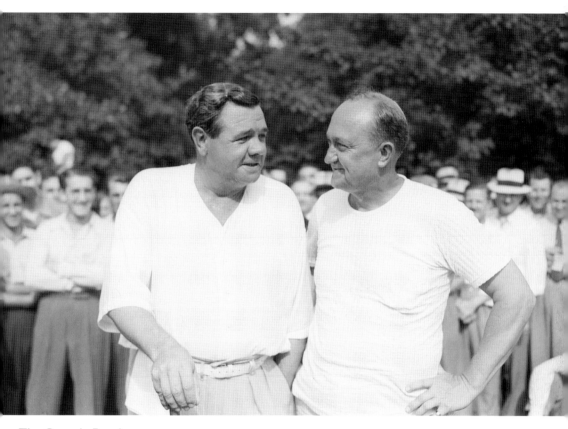

The Georgia Peach

What Gordie Howe was to hockey, Tyrus Raymond "Ty" Cobb was to Detroit baseball. Considered the greatest batter in baseball history, even his many foes were quick to recognize his incomparable abilities. Cobb was born in 1886 in Narrow, Georgia, a small community near Atlanta. Realizing his interest in baseball at a very young age, Cobb played with several local teams before signing with the Augusta Tourists of the South Atlantic League in 1904. The following year, Tourists management sold Cobb to the Detroit Tigers organization. Despite ending his first season with the Tigers with a batting average of only .240, Cobb showed considerable potential. In 1906, his performance behind the plate improved, enabling him to achieve a .316 average. In 1907, he was moved from center to right field and batted a .350 average, helping the team win the American League pennant. Despite repeating the feat in 1908 and 1909, the Tigers lost the World Series each year. Over the next 19 years, Cobb's on-field achievements and off-field persona shaped his legacy as a cunning competitor, an irascible teammate, and an organizational liability. Relying on cold calculation as much as on athletic ability, he frequently manipulated the game to his advantage. In a 1911 matchup with the New York Highlanders, after scoring two runs batted in (RBI) on a double, Cobb ignited an argument with the opposing catcher and the umpire who called him safe at second base. The participants were so engrossed in their confrontation that no one bothered to call time. Noticing this, the genius from Georgia continued undetected on to home plate, scoring another run. The following year, he displayed his irritability. During a road game with the Philadelphia Athletics, Cobb was forced to listen to an aggressive heckler. Eventually losing his temper, he vaulted into the stands and attacked the offender, even after discovering that the man was handicapped. American League president Ban Johnson was infuriated and ordered Cobb suspended, triggering a threat from his teammates to strike if he were not reinstated. The result was professional baseball's first strike, which lasted just one day. Although Ty Cobb and Babe Ruth (pictured together here) approached the game somewhat differently and viewed each other with a degree of suspicion, they expressed mutual respect after retirement.

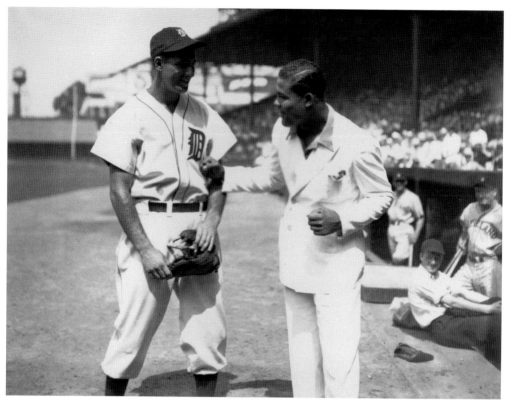

Hank "The Hebrew Hammer" Greenberg

A stellar player who also added class to the Tiger organization, Hank Greenberg signed with the team in 1929 (for the impressive sum of $9,000—a small fortune at the time). After a few years in the farm system, the native New Yorker hit .301 in 1933, his first full season at the major-league level. In September 1934, while the team was in a pennant race with the New York Yankees, Greenberg initially decided he would forgo playing on the upcoming Jewish holidays. He eventually did play on Rosh Hashanah, hit two home runs against the Boston Red Sox, and was thanked with a Hebrew "Happy New Year" on page one of the next day's *Detroit Free Press*.

The Brown Bomber

More than just a champion boxer, Joe Louis (born Joseph Louis Barrow) can be considered Detroit's Jackie Robinson. Arriving in Detroit in 1926 from LaFayette, Alabama, Louis went on to a professional career of 66 wins—including the famous 1936 rematch with Max Schmeling—and only three losses. Interrupting his career for military service in World War II, Louis was assigned to entertain troops by participating in exhibition fights. Viewed as perhaps the first black national icon, Louis also fought racial segregation while earning the admiration of many white Americans.

One Tough Quarterback

The Detroit Lions' acquisition of quarterback Bobby Layne in 1950 led the team to NFL championships in 1952, 1953, and 1957. A native of Texas, Layne displayed virtually unheard-of performances. During the 1946 Cotton Bowl against Missouri, he had led the University of Texas to a 40-27 win, and was directly involved in the scoring of each point. Layne typified the era's rough style of play and was the last professional quarterback to play without a face mask. Legend states that after being traded in 1958, an upset Layne predicted the Lions would not win a championship for another 50 years—a prophesy which has, regrettably, come true.

Mr. Detroit Tiger

Today, the phenomenon of a star player spending his entire career with a single team is rare indeed. Al Kaline, a native of Baltimore, Maryland, spent his 21-year career in professional baseball exclusively with the Detroit Tigers. His standout talent as a hitter and outfielder enabled him to bypass playing in the minor leagues, and he signed with the Tigers in 1953 at the age of 19. Over the following two decades, Kaline rarely had a bad year, earning 10 Golden Glove awards, participating in 18 All-Star games, and becoming only the 12th major-league player to achieve 3,000 hits. He was inducted into the Baseball Hall of Fame in 1980, his first year of eligibility. After retirement, Kaline never left the Tigers organization, holding a variety of front-office positions. (Courtesy of George Eichorn.)

George Lish

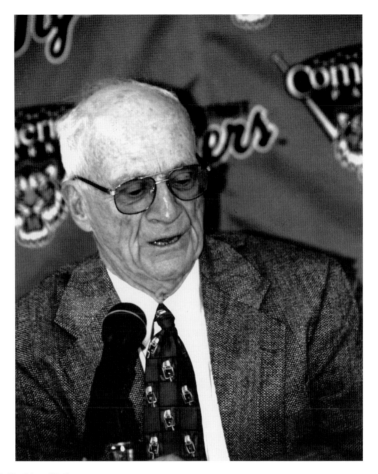

The Tigers' Golden Voice

Ernie Harwell is thought of more as a civic institution than simply a sports broadcaster, and his southern drawl calling Tigers games on radio are fixed in the minds of any fan born before 1980. Arriving in Detroit in 1960, the Georgia native had baseball in his blood. At the age of five, he had been a batboy for the Atlanta Crackers of the now defunct Southern Association. After attending Emory University in Atlanta, Ernie combined a degree in journalism with his passion for the game by working as a sportswriter and editor at the *Atlanta Constitution,* while calling Crackers games on local radio. Moving to the northeast, he did stints in the broadcast booth for the Brooklyn Dodgers (1948–1949), the New York Giants (1950–1953), and the Baltimore Orioles (1954–1959). After being recruited to Detroit in 1960, Harwell entertained generations of Tiger fans with vivid, compelling descriptions of the play-by-play and coining several clever sayings, including, "He stood there like a house by the side of the road" when describing a called strike, and, "A gentleman from Saginaw, Michigan [or some other city] will take that ball home tonight" when referring to a ball hit into the seats. The sense of loyalty was mutual. Over the years, Harwell and his wife, Lulu, developed a strong love for the Detroit area, supporting local charities and appearing at numerous media events. In 1966, Harwell began a series of donations to the Detroit Public Library that would eventually become the Ernie Harwell Sports Collection. Included are team yearbooks, media guides, scorecards, and hundreds of other pieces of sports-related ephemera with an emphasis on the Detroit Tigers. Today, these items are housed in a special area at the Main Library called the Ernie and Lulu Harwell Room, which even features a mock broadcasting booth. Working until age 84, Harwell did occasional guest appearances on national television broadcasts. Sadly, he became a victim of cancer some years later and died in 2010 at the age of 92. (Courtesy of George Eichorn.)

Man of the Year, 1984

George Lee "Sparky" Anderson earned his nickname as a struggling but determined minor-league infielder during the 1950s. Despite his efforts, his major-league playing career lasted only one year, ending when he completed the 1959 season with the Philadelphia Phillies. Returning to the minors, Anderson played four years with the Triple-A Toronto Maple Leafs (not to be confused with the namesake hockey team), where management noticed his ability to effectively mentor other players. Accepting the suggestion that he consider managing, Anderson spent the next several season with a variety of minor-league teams and experienced considerable success. In 1969, he broke into the major leagues as third-base coach of the San Diego Padres, and the following year he was named manager of the Cincinnati Reds. This began the era of the "Big Red Machine," with Anderson leading the team to the National League pennant in 1970, 1973, and 1975. He considered the 1976 Reds, who swept the New York Yankees in the World Series, to be the finest team of his managerial career. After being appointed manager of the Detroit Tigers in 1979, Anderson built another legendary baseball dynasty. Nurturing the promising talent of pitchers Jack Morris and Willie Hernandez and the hitting strength of Kirk Gibson and Alan Trammel, Anderson's efforts came to fruition in a truly magical season in 1984. That year, the Tigers became the first team since the 1927 New York Yankees to hold first place for the entire 162-game season. Capping the year was the Tigers' victory in the World Series over the San Diego Padres in five games. The energy from the win was electric, uniting the greater Detroit community in a truly remarkable way. Anderson, however, considered his proudest achievement in Detroit the establishment of his charity CATCH, or Caring Athletes Teamed for Children's and Henry Ford Hospitals, which raises funds to pay for health care for children in need. Anderson retired at the end of the 1995 season but continued to visit Detroit to monitor the progress of CATCH and to maintain local ties. His death in 2010 was mourned throughout the greater Detroit community.

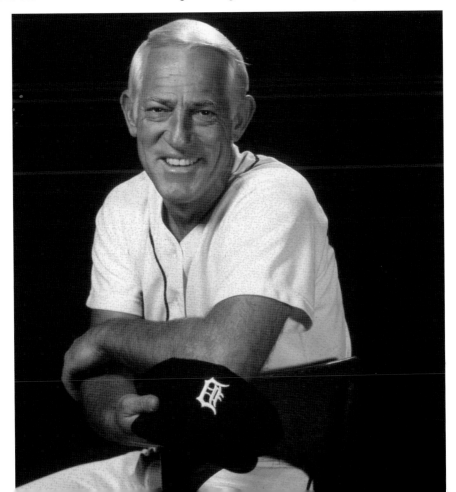

Home Grown Talent

As a member of Northwestern High School's championship baseball team of 1959, Willie Horton found his passion early. Signing with the Tigers soon after, Horton stayed with the team until 1977, playing left field and, later, designated hitter. Horton, along with Mickey Stanley, Jim Northrup, Norm Cash, and Al Kaline, was integral to the synergy behind the 1968 World Series win. On July 23, 1967, after the Tigers beat the New York Yankees, Horton—still in uniform—went to the area of Twelfth Street where an urban insurrection had begun hours earlier. Despite his efforts to calm the crowd, the violence continued.

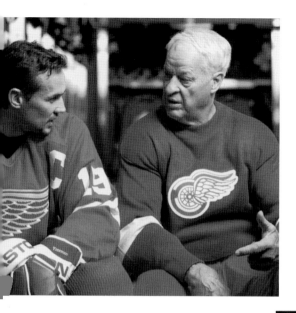

The Longtime Captain

Throughout their history, the Detroit Red Wings have boasted an array of quality players, including a few true hockey legends. Steve Yzerman (left) belongs in the latter group, the most recent member of an elite club that includes Gordie Howe, Sid Abel, Ted Lindsey, Terry Sawchuk, and Alex Delvecchio. Recruiting the 18 year old from Cranbrook, British Columbia, in 1983, management immediately noticed his considerable talent and wasted no time putting him on the ice. Yzerman did not disappoint, staying at the right-wing position for 23 years, including 19 as team captain. He ranks eighth in NHL history for goals scored (692) and fourth in games played (1,514) as a Red Wing. In January 2007, his number, 19, was retired—just one of his many honors. (Courtesy of George Eichorn.)

Isiah Thomas

By far the most spirited member of the Bad Boys, Thomas was essential to the team's success. During the mid-1980s, the Pistons advanced progressively further in post-season play each year, reaching the first round playoffs in 1984, the Eastern Conference semifinals in 1985, and the conference finals in 1987. In the crowning achievement of his playing career, which ended in 1994, Thomas was named Most Valuable Player of the 1990 NBA Finals. He continued in basketball as a coach and executive, working for such teams as the Toronto Raptors, the Indiana Pacers, and the New York Knicks.

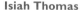

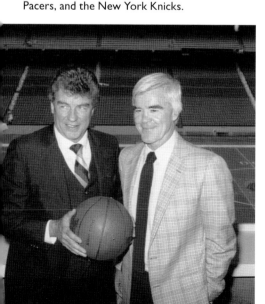

Leader of the Bad Boys

Chuck Daly (left) personified true class, both on and off the court. Hired by the Detroit Pistons organization in 1983, Daly brought well-honed expertise acquired from a career with the University of Pennsylvania and the Cleveland Cavaliers. Working with owner William Davidson, Daly built a contending team, acquiring point guard Isiah Thomas, center Bill Laimbeer, and guard Vinnie Johnson. Daly's efforts improved the team's performance, making him a local celebrity. His hard work produced an aggressive style of play that earned the team's "Bad Boys" nickname, and culminated with back-to-back NBA championships in 1989 and 1990.

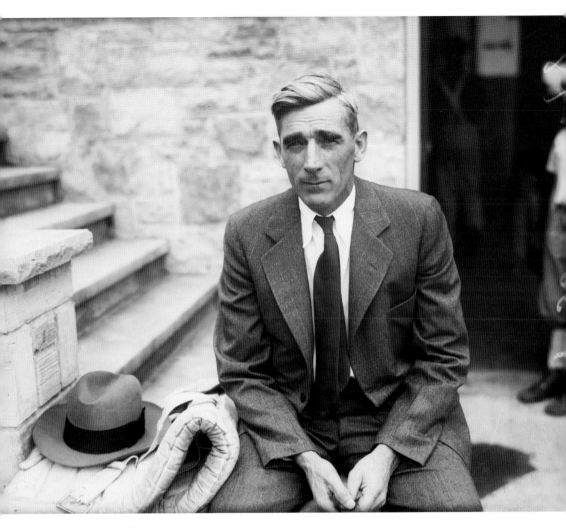

A Passion For Speed

Garfield "Gar" Wood's successes represent a different type of Detroit sports story. As an inventor and businessman, his activities included manufacturing and selling powerboats, truck bodies, and hydraulic lifts. But his first love was boat racing. In 1920, he set a new water-speed record of 74 miles per hour on the Detroit River in his boat, *Miss America*. During the next 15 years, Wood built ever-more sophisticated boats (all with the same name) and won numerous titles, including five Gold Cups and nine Harmsworth Trophies, in competitions on the Great Lakes and on the East Coast. Wood's company continued producing sleek, elegant speedboats until 1947. Noted for their classic Streamliner silhouette, surviving examples today are highly prized collectibles.

CHAPTER EIGHT

Demagogues, Disrupters, and Dissidents

Human beings' imperfections are reflected all too often in the history they shape. Within the range of human emotions, fear is usually the root cause that motivates racism, segregation, and violence. Frequently, this fear is generated by perceived threats to what an individual or group holds dear—their religion, their resources, their neighborhood, or their way of life. Bigoted preconceptions, as well as benign misunderstandings, serve as the fuel for hate.

Charismatic leaders who capitalize on social anxieties are rarely in short supply. The ability of demagogues to take advantage of public hysteria and organize their followers for mayhem has been demonstrated several times in Detroit's past.

This chapter exposes a number of these scoundrels and does so for an important reason. According to the Spanish philosopher George Santayana, "The one who does not remember history is bound to live through it again."

These profiles are offered in that spirit.

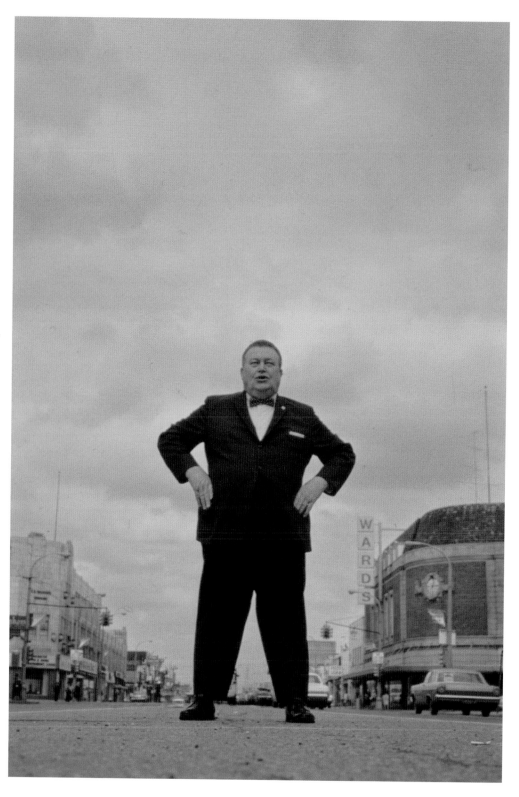

The Dictator of Dearborn

Pristine parks, impeccably maintained swimming pools, a municipal summer camp outside the city limits—these were just a few of the amenities Orville Hubbard showered on his constituents during his 36-year reign (1942–1978) as mayor of Dearborn. Financed by heavy tax revenues paid by Ford Motor Company, Hubbard's largesse achieved its intended effect, keeping him in office for decades where, in addition to providing superb city services, he had the freedom to enforce strict racial segregation in keeping with his intense hatred of African Americans. In an interview with the *New York Times* in 1968, Hubbard explained his opposition to integration, asserting that, if children of different races were to attend the same schools, "the next thing you know, they're grab-assing around, and then they're getting married, and having half-breed kids." He asserted that this would lead to "a mongrel race [and, consequently,] the end of civilization." Virtually no blacks were able to purchase homes in Dearborn during Hubbard's long term of office, despite its sharing a considerable boundary with Detroit. During the early years, city workers would pass out pamphlets to residents extolling the mayor's racial views. His campaign slogan, which he reused each election, was "Keep Dearborn Clean," a not-too-subtle code which really meant "Keep Dearborn White." Hubbard was also known for his many eccentricities. Quotes covering his office walls espoused hard work, patriotism, and loyalty; a time clock and large scale adorned his waiting area; and new hires at city hall were required to write an essay commenting on the famous tract "A Message to Garcia" by Elbert Hubbard. Even so, Orville Hubbard could occasionally top himself. In 1950, he refused to pay a fine for libeling a rival politician. The court responded by ordering him not to leave Wayne County. Two years later, with the situation still unresolved and the order still in effect, Hubbard decided to attend the Republican National Convention in Chicago. Enlisting two cohorts, the trio boarded the train wearing clown makeup. Court officers soon arrived but could not figure out whom to arrest.

The Radio Priest

Rev. Charles Coughlin, who was directed to establish the Shrine of the Little Flower Catholic Church in 1927, understood the new medium of radio and how he could use it to his advantage. Soon after holding the first services at his new parish, Coughlin began to broadcast them locally on WJR-AM. The initial content of the programs was purely religious and was intended to encourage donations to his financially struggling church. As the Depression arrived, however, Coughlin could see both the material as well as spiritual poverty of the nation. His radio sermons became more political in nature, and in 1930, CBS began to broadcast his program nationally. In the 1932 presidential campaign, Coughlin strongly supported Franklin Delano Roosevelt, often repeating the tagline "Roosevelt or Ruin," and was rewarded with an invitation to speak at the Democratic National Convention. Soon after Roosevelt took office, however, the priest's relationship with him soured. Coughlin viewed Roosevelt's New Deal programs as inadequate. The rise of the Third Reich in Germany spawned the isolationist America First movement, with which

Coughlin closely identified. His radio talks soon became anti-Semitic in nature, making incredible claims that Jewish-owned banks, many in the United States, were responsible for financing Hitler's rise to power. In 1934, Coughlin established the National Union for Social Justice, an organization dedicated to workers' rights. Allying itself with the Union Party in 1936, it advocated complete federal control over the nation's economic system and total noninvolvement by the United States in any European war. After Roosevelt's reelection in 1936, Coughlin's radio speeches grew even more vitriolic, and in 1938, his *Social Justice* newspaper went so far as to publish *The Protocols of the Elders of Zion*, a rabidly anti-Semitic and discredited text written in Russia during the early 20th century. Eventually, several radio stations refused to continue carrying his broadcasts. In 1937, after the death of Detroit bishop Michael Gallagher, Coughlin was silenced by his successor, Cardinal Edward Mooney. Coughlin reverted to the role of a simple parish priest until his retirement in 1966.

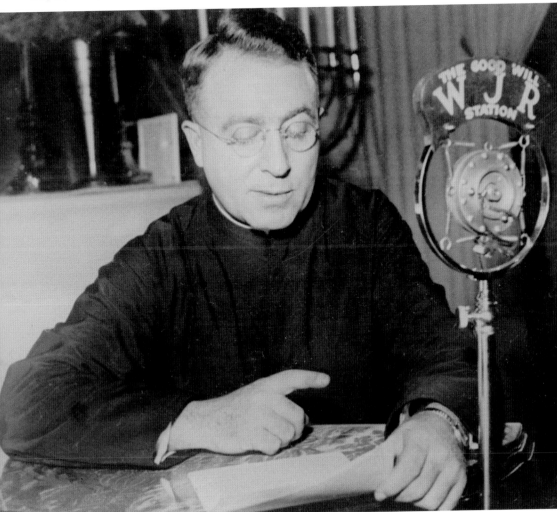

The Enabler

In 1926, businessman George Richards (top), along with a small group of partners, purchased a fledgling new radio station, WJR. Over the next several years, he also acquired stations in Cleveland and Los Angeles, forming the nucleus of what he named the "Goodwill Station Group." In addition to his radio empire, Richards also purchased the Detroit Lions football team in 1934. But he soon began to use his corporate empire for unsavory purposes. By hosting Rev. Charles Coughlin's increasingly anti-Semitic radio broadcasts, Richards drew the attention of federal authorities. It was soon revealed that he shared many of the priest's bigotries against Jews, labor unions, blacks, and political liberals. Long after Coughlin was silenced, Richards battled the FCC, which claimed he had not acted in the public interest and was considering terminating his stations' licenses. Richards spent millions defending himself, only to die before the matter could be resolved. (Courtesy of WJR-AM.)

The WJR Management

Mr. G. A. Richards
Founder and Principal Owner

Mr. Harry Wismer,
Executive Assistant to the President
and General Manager of WJR

RADIO – THE AMERICAN WAY

WJR

Dial 760 AM
96.3 FM

The Goodwill Station

DETROIT

Ford's Thug in Chief

In 1937, Henry Ford could see the growing influence of the labor movement and took action. He turned to Harry Bennett, head of Ford's euphemistically named "service department," and told him to "take care of things." Bennett was a force to be reckoned with. Hired by Ford years earlier, he commanded a private security force of more than 8,000, made up of former boxers and ex-convicts, who ruled the Ford facilities with an iron hand. On May 26, 1937, as UAW organizers attempted to distribute leaflets at the Rouge plant, union leaders Walter Reuther, Richard Frankensteen, and others were approached by Bennett's men and beaten savagely. The security force then attacked the reporters and photographers assembled, destroying photographic plates. Photographer James Kilpatrick of the *Detroit News* managed to escape with what became an iconic image of the scene; its significance was such that it would inspire the creation of the Pulitzer Prize for photography.

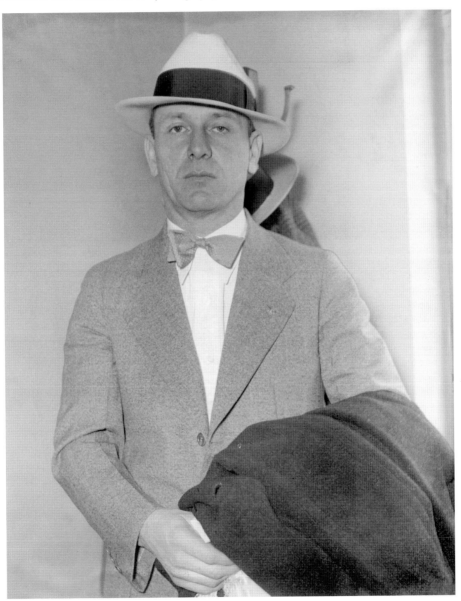

The Ku Klux Klan

Mention the name of this infamous group of white supremacists and images of the Reconstruction era in the South come to mind. The Klan's nationwide resurgence in the 1920s was a reaction to increased immigration from Eastern Europe, the growing religious diversity of the United States, and the migration of African Americans to the industrial north. Many of these newcomers arrived in Detroit in search of automotive jobs but were both shocked and saddened when confronted by a white power structure enforcing patterns of strict segregation. This was largely the result of efforts by the local Klan, whose frequent rallies at the state fairgrounds often drew crowds of curious onlookers (above). By the mid-1920s, Klan membership in the Detroit area was estimated at 35,000. During a special mayoral election in 1924, the group fielded its own candidate, Charles Bowles, who campaigned as a write-in candidate. Falling just short of victory, the closeness of the race demonstrates the extent of the organization's influence. Ideologically, the revived Klan differed little from it post–Civil War counterpart. Both saw the United States as a homeland for white Anglo Saxons and fervently believed that terrible social ills would result from integration. While their actual number was a tiny fraction of the population, the seeds of racism sown by their presence affected the attitudes of the greater community. Whites in several neighborhoods formed euphemistically named "improvement associations" for the sole purpose of excluding African Americans. Black families attempting to move into white neighborhoods were often met with threats, intimidation, and violence. Whites who sold their homes to blacks were also subject to harsh treatment. When these measures proved insufficient, white homeowners inserted clauses knows as "restrictive deed covenants" into their homes' title documents. These clauses stated that the property could only be sold to Caucasians. Unenforceable in the modern era, these and other measures inspired by the Ku Klux Klan show the profound influence the organization enjoyed.

The Stealthy Urban Terrorists

Beginning as the security arm of the Ku Klux Klan in Ohio in the 1920s, the Black Legion soon broke away from the Klan and spread its influence to Detroit. Members shared many of the same goals as the Klan but used violence more liberally. They wore ghoulish black robes trimmed in red, were only active at night, and attacked those they perceived as threats to what they considered rightfully theirs, such as jobs and desirable neighborhoods. Many members held jobs in the automobile industry and city government and would often inform authorities of what the group believed were growing communist incursions into America. Findlater Hall near Fort Wayne (below) was one of their purported meeting spots. Most influential local members were convicted of murder in 1936 (above) for the murder of Charles Poole, an employee of the federal government, and their influence subsequently diminished.

The Detroit Mob

Detroit's emergence as a major industrial center in the early 20th century attracted thousands of European immigrants, including many from Sicily and Naples—areas of Italy particularly known for the tradition of underworld criminal activity known as the Camorra, or "Black Hand." The newcomers showed no sign of abandoning these customs once they reached American shores. Throughout much of the 20th century, Detroit would experience frequent incidents of murder and violence while rival gangs sought to protect their turf and their lucrative business interests like illegal liquor, gambling, and prostitution.

While the history of organized crime in Detroit is complex and involves numerous players (some of whom defied the Italian stereotype), the two major factions that emerged by the Prohibition era were the River Gang (also known as the Detroit Partnership), and the Purple Gang. The Partnership began in 1931 after the murder of Detroit mob boss Chester La Mare. Stepping into the void were Angelo Meli, William "Black Bill" Tocco (below), and Joe Uno Zerilli. Tocco, later convicted on federal tax evasion charges, served eight years in prison. During that time, Zerilli would step in to head the "Detroit Ruling Council." Although he retired to Florida following his release, Tocco continued to exert considerable influence on local mob activities, including the construction and operation of Hazel Park Raceway in the late 1940s. He died of natural causes in 1972. Joe "Scarface" Bommarito (right), another leader of the Partnership, was believed to be linked to the murder of radio journalist Jerry Buckley on July 23, 1930. Buckley gained his celebrity status largely due to his leadership in the successful effort to recall Mayor Charles Bowles, who had recently unseated incumbent John Lodge. Bowles, the candidate backed by the Ku Klux Klan, had come under fire in 1924 for terminating Harold Emmons, the popular police commissioner. Buckley was known to have underworld ties himself, but despite his many enemies, investigators focused on Bommarito. At trial, however, Bommarito was acquitted, and he went on to be an influential leader in the River Gang. (Courtesy of Scott Burnstein.)

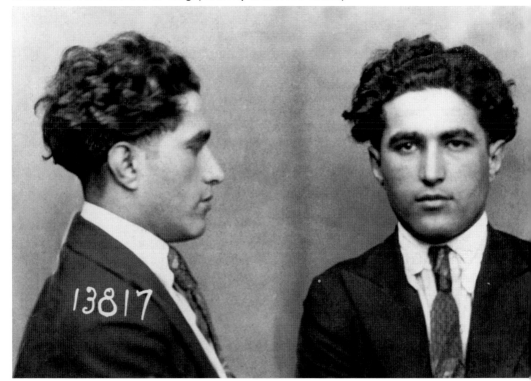

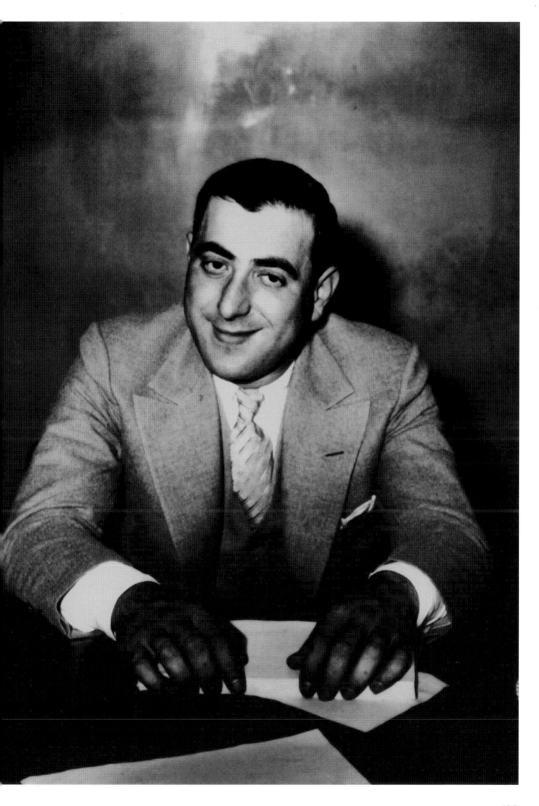

The Purple Gang

While the Detroit Partnership had affiliations with its counterparts in other cities, the Purple Gang stood out as a singular local institution. And, while the Italians were noted for ruthlessness, their level of brutality paled in comparison to the Purples'. Comprised predominantly of brothers from four middle-class, Jewish families, the group grew up on the lower-east-side community along Hasting Street between 1910 and 1920. The children of immigrant laborers, many saw little opportunity in legitimate occupations. Members included Abe (below, right), Joey, Izzy, and Ray Bernstein; Harry, Sam, and Lou Fleisher; Harry and Philip Keywell; and Sam Davis (below, left), the group's "enforcer." The group members began their careers by selling "protection" to area merchants (actually a threat of vandalism to their establishment if the merchant refused to pay). Involvement with other underworld activities (gambling and prostitution) soon followed, but the Purples made their biggest mark through the illegal liquor trade, controlling at least 50 percent of the alcohol trafficking in the city. In addition to bringing booze in themselves, the group frequently hijacked other gangs' hauls, killing anyone who stood in their way. Developing a sophisticated

ETROIT POLICE DEPARTMENT

AM DAVIS (W)

alias The Gorilla

Classification..........

Ref..........

| 1.—Right Thumb | 2.—R. Index Finger | 3.—R. Middle Finger | 4.—R. Ring Finger |
| 6.—Left Thumb | 7.—Index Finger | 8.—L. Middle Finger | 9.—L. Ring Finger |

WANTED FOR MURDER

This Department holds warrant for Sam Davis, alias The Gorilla, for the murder of Harry Gold, whom he shot about 12:30 A.M., February 17, 1932, in the left chest and left abdomen during an attempted hold-up. He was dead upon admittance to Receiving Hospital.

DESCRIPTION: Jewish; age, 24; 5 ft. 4 in.; 140 lbs.; florid complexion; protruding lips; hazel eyes; light brown hair.

Warrant is also for John Doe (no description) and for Nate Karp. See Circular No. 3383 for description of Nate Karp.

Wire all information to

JOHN P. SMITH,
Superintendent of Police,
DETROIT, MICHIGAN.

Circular No. 3384. Homicide File No. 2573.
April 5, 1932.

27718
7-2-30

chain of distribution from suppliers in Windsor, the organization profited handsomely throughout the 1920s. Word of their success traveled to Chicago, and in 1927 Al Capone sent scouts to Detroit to investigate possible expansion. At a meeting with the Purples, the visitors were forcefully told to "keep your hands off our river." Intimidated but impressed, Capone joined forces with them, enlisting the Purples' help in the St. Valentine's Day massacre, for which hit men Abe Axler (below, left, with attorney) and Eddie Fletcher (below, center, with attorney) were dispatched to Chicago. The Purple Gang's reign of terror came to an end after the Collingwood Street Massacre on September 16, 1931. Members of the Little Jewish Navy, a onetime subgroup of the Purples who had decided to run their own syndicate, were summoned to an apartment on Collingwood Street, purportedly to negotiate a truce. On orders from Abe Bernstein, Purples Irving Milberg, Harry Keywell, and Ray Bernstein waited for a prearranged signal and opened fire, killing Hymie Paul, Isadore Sutker, and Joe Lebowitz. Convicted of first-degree murder, the three gunmen were put away for life. (Courtesy of Scott Burnstein.)

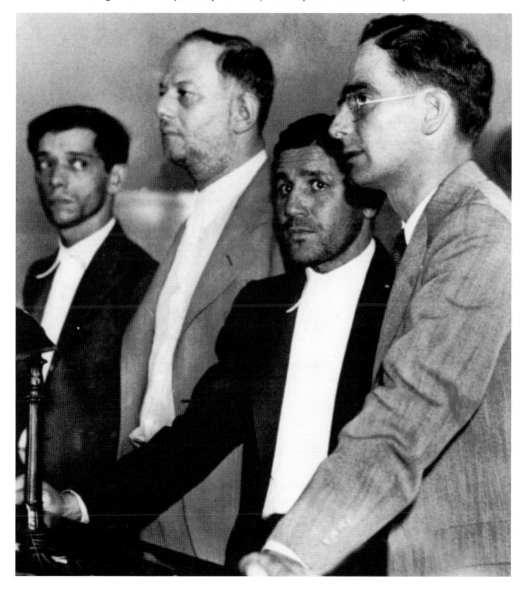

BIBLIOGRAPHY

Bak, Richard. "(Frank) Murphy's Law." *Hour Detroit*, September 2008.

Baseballhall.org

Burnstein, Scott. *Motor City Mafia: A Century of Organized Crime in Detroit*. Charleston, SC: Arcadia Publishing, 2006.

Detroit.about.com

Gallagher, John, and Eric J. Hill. *AIA Guide: the American Institute of Architects Guide to Detroit Architecture*. Detroit, MI: Wayne State University Press, 2003.

Gavrilovich, Peter, and Bill McGraw, eds. *The Detroit Almanac: 300 Years of Life in the Motor City*. Detroit, MI: *Detroit Free Press*, 2000.

hall.michiganwomen.org

inventors.about.com

Lutz, William. *The News of Detroit*. Boston, MA: Little, Brown and Company, 1973.

McGraw, Bill. "Remembering Ravitz." *Metro Times*, April 21, 2010.

Nadell, Pamela Susan. *Conservative Judaism in America: A Biographical Dictionary and Sourcebook*. Westport, CT: Greenwood Publishing, 1988.

Sharoff, Robert, and William Zbaren. *American City: Detroit Architecture 1845–2005*. Detroit, MI: Painted Turtle Books, 2005.

Spratling, Cassandra. "Arthur Johnson, a Civil Rights Icon and Comrade of Martin Luther King, Jr., Dies at 85." *Detroit Free Press*, November 2, 2011.

Stolberg, Mary M. *Bridging the River of Hatred: The Pioneering Efforts of Detroit Police Commissioner George Edwards*. Detroit, MI: Great Lakes Books, 2002.

Sugrue, Thomas L. *The Origins of the Urban Crisis: Race and Inequality in Postwar Detroit*. Princeton, NJ: Princeton University Press, 2005.

Peebles, Robin. "Fannie Richards and the Integration of the Detroit Public Schools." *Michigan History Magazine*, 1981.

www.charleslindbergh.com

www.cranbrookart.edu

www.gphistorical.org

www.michigan.gov/dnr

INDEX

AN IMPRINT OF ARCADIA PUBLISHING

Find more books like this at
www.legendarylocals.com

Discover more local and regional history books at
www.arcadiapublishing.com

Consistent with our mission to preserve history on a local level, this book was printed in South Carolina on American-made paper and manufactured entirely in the United States. Products carrying the accredited Forest Stewardship Council (FSC) label are printed on 100 percent FSC-certified paper.